Degas

Phidal

> "Up to the present, Degas has known better than anyone else how to capture the spirit of modern life."
>
> Edmond de Goncourt

Degas, whose real name was Edgar-Germain-Hilaire de Gas, was born July 19th, 1838. His was a comfortable bourgeois family, and except for a brief period after the death of his father, Degas always lived a life of ease. This was in contrast to the legendary image of the poverty-stricken Impressionist. Favoured in appearance as well as life style and work, this great painter had an aristocratic, almost arrogant air about him.

His family history perhaps holds a key to his stubborn and anti-social nature. His paternal grandfather was the founder of a bank in Naples where he had fled after the Revolution, during the Reign of Terror. His father Auguste, also a banker, had the reputation of being refined and cultivated. A connoisseur and lover of the arts, he introduced young Edgar to music by taking him to the opera, and to art by introducing him to the most important collectors in Paris, one of whom was Edouard Valpinçon, a friend of Ingres.

His mother Célestine Musson had come to Paris from New Orleans to finish her education in France, as was appropriate for the daughter of one of Louisiana's most prominent families. The childhood and youth of Edgar and his four brothers and sisters, Achille, René, Thérèse and Marguerite, was a rich and happy one. Only the death of their mother in 1847 disturbed their peaceful existence. When he had finished his schooling, to please his father, Degas enrolled in the faculty of law at the university in Paris. But he spent most of his afternoons at the Prints Department of the National Library where he studied and copied the works of the great masters. Besides looking at the engravings of Dürer, Rembrandt, Goya and Mantegna there, he also went often to the Louvre where he studied its paintings, seduced in particular by the French artists Clouet and Le Sueur, the Italian and Dutch artists, and Holbein. He began to feel the need for his own studio and decided to transform a room in his father's house near the Tuileries Garden into one.

His first teacher was Barrias, who was soon replaced by Louis Lamothe, a mediocre student of Jean-Dominique Ingres, who nevertheless tirelessly drummed in Ingres's teachings. These lessons proved to be fundamental for Degas (as he renamed himself very early in his career) for he never forgot the works of Ingres, whose influence on him was great, nor would Degas forget the words Ingres spoke to him on one of their rare meetings: "Never draw from nature, young man. Always draw from memory and after the works of the great masters!" Thus it was in 1855 that although, thanks to Lamothe, he was accepted into the course of study at the Ecole des Beaux-Arts, he chose instead to go directly to Italy. There he could learn about that country first hand, experiencing directly its characteristic landscape, its atmo-

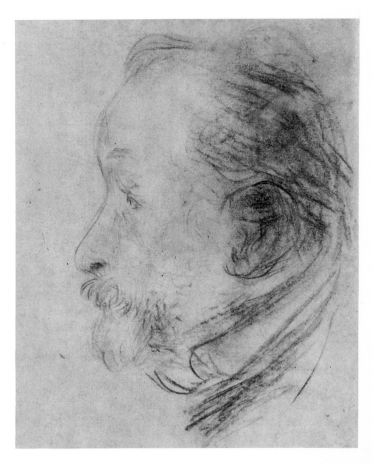

Self-portrait, Private collection

sphere and the colours so typical of such artists as Giotto, Botticelli, Bronzino, Leonardo, Raffaello, and Paolo Uccello. He filled his travel notebooks full of sketches and comments which, even today, are a great testimony to his development as an artist. He had already once been to Italy in 1854 to visit his grandfather in Naples and after that, he went back every year until 1860. Among the loveliest remembrances he has left us are the landscape drawings in ink or sepia wash inspired by Claude Lorrain.

Of his many trips to Italy, the most important must certainly be the one he took in 1858. The route he chose for travelling from Rome to Florence was much longer than his usual one, and it included stops in Orvieto, Perugia, Arezzo and Assisi. It was during this period that he wrote about Luca Signorelli and "his love of movement", of Giotto's surprising sense of drama and expression and of the emotion he felt when he understood through the works of the great masters themselves that all "those people were very conscious of life and did not much deny it." He arrived in Florence in August and decided to remain there for a time. As it turned out, the artist Gustave Moreau was also in Florence at the same time. For Degas, it was a special occasion because he was able to enjoy the hospitality of his father's sister, who was married to Baron Bellelli. He must have already thought of painting a family portrait of the Bellellis for he had previously done sketches of his cousin Julie. A few years later, in his studio in rue Madame in Paris, using the series of studies and drawings he had made in Florence, he painted a portrait, *The Bellelli Family* which was to be the first of a new genre of portrait painting. It must certainly be considered as one of the most modern works of that century, not only because of the clear contrast between the rigorous classical drawing and certain details, such as the carpet or the flowers on the wallpaper that are intentionally left imprecise, but above all because of the unexpected expressions he has given his subjects. They seem to have been caught by surprise, captured in natural poses, in the midst of thought; their positions do not seem studied at all. One of the two young girls is looking at the painter, while the Baron has his back to the artist. It is an energetic painting which, through careful observation of the pyschology of the subjects, emphasises the intimate nature of the composition rather than its façade.

Like the old masters, Degas was eager and, at times, even impatient to transpose on canvas his personal experiences of the times in which he was living. For this reason, in the years 1860 to 1865, when he was working on *The Bellelli Family*, he was also developing other motifs which reflect his strong desire for new experiences. How else can one explain his transition from the large historical paintings which were his homages to the classical painters he still admired to his first studies of race horses or the originality of portraits like *A Woman with Chrysanthemums*?

His first historical paintings had titles that clearly suggested their themes: — *Young Spartans Exercising*, *Semiramis Founding a Town*, *Alexandre and Bucephal*, *The Daughter of Jephthah*, *War Scenes in the Middle Ages* or *Les malheurs de la ville d'Orléans* — but they are not among his most pleasing. The reason for this is simple. Even though these tableaux showed the influence of Ingres, and their preliminary drawings are very well executed and even beautiful, when it came to the paintings themselves, Degas did not seem able to resist putting all the different sketches into one composition. The works were accused of lacking cohesiveness and "éclat". And in fact, they are not as fine as his later paintings, but what thought they show and what lightness in the nuances of their colours!

Then, in 1872, a painting with new breadth, *At the Races* was produced. Degas has portrayed his subject at the moment the race is about to start, and in its images, colour becomes movement. The jockeys in the foreground correspond to the group of spectators in the middle ground, and in turn, they are placed below and relate to the riders in the background.

A Woman with Chrysanthemums, painted in 1865, almost seems like a photograph because the subject looks so natural and immediate.

Compared to others that Degas had been painting, it is another surprising portrait. The woman, placed at the extreme right of the composition, is completely self-absorbed, distant, and unconcerned about being observed. In fact, it is the vase of flowers in the centre which dominates the scene.

Degas's acquaintance with Edouard Manet and then, through him Bazille, Cézanne, Fantin-Latour, Pissarro, Renoir, Sisley, and Zola was not by chance. It happened a year before the exhibition at the "Salon des Refusés" of Manet's *Déjeuner sur l'herbe* that "inconvenient bourgeois idyll" that created such a scandal both with the public and the press. What upset the Parisian bourgeoisie most about Manet's painting was not the nude woman sitting in the grass, nor was it the artist's dazzling interpretation of contemporary society. Rather, it was his shocking use of revolutionary techniques based on contrasts of light and colour.

Like Manet, Degas was also feeling the urgency and need to "belong to the times and to paint what he saw." From that point on, carried along on a tidal wave of social and artistic turmoil and influenced by Manet's new techniques, Degas gave colour an ever more decisive role in his work, which allowed him to interpret and to bring out the colours in a face, the small details in a room, or movement in an entire scene.

But in doing so, he did not forget the preciseness of the Dutch artists nor the rules he had learned from the great masters.

He was also inspired by the Japanese prints of artists like the great innovator Hokousai (discovered in 1856 by the engraver Félix Bracquemond), who reproduced details with calligraphic rigour in their natural setting, things like volcanoes, villages, trees, and animals, and men and women with almond-shaped eyes going about their daily life. But among Hokousai's creations, what perhaps most struck the painters on the other side of the world — who were always storing ideas and looking for new and stimulating experiences, and what remains among the most famous images even today — was his drawing of a giant wave as it was about to crash onto the sea, a moment before it broke.

The tension and pathos of the scene, one that captures the attention of the spectator in a dazzling and spectacular fashion, represented for the new painters (as would photography later) one of the greatest sources of surprise and discovery of its time, and it brought with it a means of confronting and confirming the results of their own experiments.

In many ways Degas was an artist ahead of his time; he was even ahead of photography. Twenty years before the projection of the first photographs of a galloping horse taken by Eadwearch Muybridge, Degas made his own so-called "instant" paintings.

This was around the year 1870. Through the intervention of Désiré Dihau, a friend who played the bassoon in the Opéra orchestra, he met other musicians and he began to study and draw them. In a note to himself, he wrote: "Series on instruments and instrumentalists — their form — the twisting arms and shoulders and neck of the violinist, for example, the puffed up cheeks and lips of the bassoon player, the oboist..." He took notes and he painted. *The Orchestra of the Opéra* is only one title among a long series of paintings that had as their theme the world of the spectacle, the theatre seen from the other side of the footlights, from the side of those who performed and lived it. After gathering together many drawings and sketches, he would file them in his memory as usual, thus drawing on his equally great ability to reconstruct an image with great realism (if you were to compare him with a figure in the literary world, you might liken him to Flaubert or Tolstoy). He then gave these images a new feeling of space and light. On stage, one could recognise the principal dancers lit up by the footlights. But it is not until 1872 that we find whole groups of dancers, at the bar or busy watching themselves in the mirror, as in *Ballet Rehearsal Room at the Opéra*.

Another portrait depicting everyday life was also painted around that time, in 1869 to be precise. In *Woman Ironing*, Degas has chosen a surprising new subject, that of a woman doing ordinary work. *By the Seaside*, a pastel executed at the time of *Woman Ironing*, and some-

what different from the artist's usual themes, i.e., individuals as opposed to nature, is perhaps best explained by the artist himself. Degas, who was openly in conflict with a certain style of painting of the day, said: "It is courageous to tackle nature head on through its great planes and great lines and cowardly to do it through facets and details." Nor did he mince words later when, speaking of the Impressionists' paintings done out-of-doors, he declared: "A painting is above all a product of the artist's imagination; it should never be a copy. The air that one sees in the paintings of the masters cannot be breathed." It should be noted that, unlike Manet, Degas did not improvise in his painting and that he always followed the rules of Ingres, Delacroix and the classic painters. The originality that slowly emerged in his choice of subjects and in his compositions is based on careful study. Reflection was his strength and it would have been impossible for him to let himself be carried away only by inspiration and momentary impulses.

In 1872, two years after the end of the Franco-Prussian war, Degas, feeling overwhelmed by the defeat of France and by his own loneliness, went to New Orleans as the guest of his maternal uncle Michel Musson. He travelled with his brother René, who was returning home to his wife and cousin, Estelle Musson, and with another brother Achille who was going to help out his uncle in his business affairs. As he had done when he was the guest of Baron Bellelli in Florence, once in New Orleans, he began to draw the different members of the family, and in particular, Estelle. In his painting *The Cotton Office, New Orleans* although both his uncle and his brother appear as models, the atmosphere he created was quite different from the family atmosphere of the earlier portrait. The scene is set inside an office at the cotton exchange and reproduces with almost exasperating realism the atmosphere of a typical bourgeois workplace in the 19th century. An observant witness to the life of the times, Degas in this painting has advanced in his search for, and definition of, a personal style. His rigorous use of perspective and his sense of depth is accentuated by the figures perfectly placed in his composition, and by the sharp angling of the floor. The framing of the scene, the light filtering through the glass door in the background producing the effect of a Dutch interior, and the analytical portrayal of each detail give a strong sense of realism to the painting.

When he was once more back in Paris, Degas shut himself up in his studio and began to work anew. Even though he had regularly exhibited his work at the Salon each year from 1865 to 1870, no one had yet noticed him. Yet his decision not to exhibit anything in 1870 was in no way a reaction to that. Rather, it was meant as a protest to the jury, whose ideas he did not share, and as an act of solidarity with a group of artists, who (mostly because they painted scenes from everyday life, like he did) usually had their works rejected by the Salon. It was the turning point in his career. In effect, Degas joined ranks with Cézanne, Guillaumin, Monet, Berthe Morisot, Pissarro, Renoir, and Sisley, the "Impressionists" as they were ironically dubbed by the critic Leroy in 1874 after their first exhibition at the photographer Nadar's studio. From that moment on, with only one exception in 1882, Degas would participate in all the movement's exhibitions until the last one in 1886. At last the press took notice of him: "The series of new ideas also comes from the mind of a draftsman, one of our own, someone who has exhibited in the halls, a man with rare talent and an even more rare spirit." The man writing these lines was Edmond Duranthy, in an article about artists painting in the new style. Degas did not consider himself as part of any group, no matter which one it was; he had his own rules for painting. Instead of being labelled as an Impressionist, he preferred to be defined as a realist; instead of painting out-of-doors, he preferred to paint in his studio where he worked from memory; over the tranquility of the countryside, he preferred the bustle of a city with its nightlife and its women. And foremost among the women he studied, sketched and

painted were the dancers, to whom he devoted most of his time and to whom he owed the better part of his fame. With perseverance, tenacity and a growing curiosity, he "sorted through" every one of their gestures, and movements. He portrayed them full face and from behind, he drew them in profile and at an angle. He painted them before, during and after they had performed, focusing on their lightness, their balance, and their agility, capturing the effort and tension of their movements as they danced. He caught them lacing their shoes, or resting, or in a state of complete exhaustion after a difficult class or performance. In short, he observed them at every conceivable moment and in every possible way.

He often attended the dance classes at the Opéra taught by Jules Perrot. Painting the dancers alone or as a group, Degas used all the techniques at his disposal. For many of the canvases he used the geometric lines of architecture to subdivide space into equal surfaces in which he arranged his figures with insight and a strong sense of perspective. One has only to look at *Ballet Class* to understand that even the diagonal lines of the floor serve as a dynamic support to the composition, and to grasp the structural and balancing role that the figure of the dance-master, surrounded by the dancers, plays.

Degas never married. He lived alone, perhaps from timidity, perhaps from laziness or perhaps because he was too demanding. Yet women were always his favourite subject; he used them to transmit to us a glimpse of everyday life and the society of his day, expressing it in his own style and with his personal concept of reality. With a detached and completely unsensual eye, he describes to us with equal meticulousness the pressers and washerwomen who worked in the shops in Montmartre, the heavily made-up women who spent their afternoons at a café or the dressmaker's, women of pleasure doing up their hair or in the bath, and of course, women at the theatre, both on stage or off. Everything about them interested him, their characters as well as their expressions, their postures and their gestures. And when he painted them, to increase the sharpness of the image and accentuate the contrasts, he used colour and light.

After 1875, following the death of his father, Degas passed through a particularly difficult period in his life. He was forced to increase his efforts to earn money so he could help out his brother Achille who had lost everything following some bad investments. Instead of defeating him, however, these difficulties strengthened him and inspired him with new resolve and ideas. His most important works belong to the next two years. *Absinthe* and *The Café-concert at Les Ambassadeurs*, were two views of Parisian life that Degas knew well. The nightclubs and cafes of the capital were part of a world that Degas often frequented, along with other artists, men of letters and painters. This was especially true of the cafés, and one of them, the Guerbois, was the scene of lively discussions at the time the Impressionist movement was just beginning. It was eventually replaced by the Café de la Nouvelle-Athènes in Pigalle, as well as many others that also became famous as meeting places for crowds of people, both day and night. Paris was an enchanted city, "the city of lights", adored as a beacon by people all over Europe. What Degas wanted to bring out in his extraordinary work *Absinthe*, with its hint of moralism, was the contrast between the festive atmosphere of the café and the loneliness that often haunted the protagonists of his paintings. Interpreted by the actress Allen Andrée and the painter Marcellin Desboutin, the two drinkers, mute and intoxicated on alcohol, are a testimony to a reality often overlooked amidst the gaiety of that world. Besides the painting's value as a psychological study, we must also appreciate its magisterial background that shows the Japanese influence and the use of "multiple perspectives."

In *The Café-concert at Les Ambassadeurs* Degas, following an Expressionist formula, exaggerates mercilessly the grotesque aspect of the singer.

The heavy make-up and the red dress the singer is wearing seem even more violent because of the way the artificial lighting illuminates her, placing her in contrast with the black of the hats and the darker tones of the faces and the musical instruments half hidden in the shadows. The same can be said of *Cabaret* painted in 1876. Here the chromatic contrast is even more marked because of the diagonal line cutting across the pastel, clearly dividing it in two.

Degas did not stop there. He continued to work on new techniques and the various means of expression which allowed him to put his impressions down on paper. India ink, gouache and watercolour were only some of the simpler methods. But even they were not enough for him. He invented "monotypes". These were drawings he made by completely covering a copper plate with black ink and then, with a hard brush or a rag, defining light and shadow until he had created an image with which he was satisfied. To obtain a reproduction, he would press the metal plate over a sheet of paper. Taking advantage of the remaining ink, he would then press a second and even a third copy. But, of course, these copies were not as sharp as the original. They were much fainter, so faint at times that to give them new life, the painter would retouch them with pastels or even colour the monotype all over again.

When he wanted more precision in his drawing and in the contours in particular, he used a brush and diluted black ink. He then learned to ink the plate directly, sometimes even with other colours, and with oil paints as well as ink. He also did etchings, among which he has left a very lovely painting of his friend Mary Cassat, now hanging in the Louvre, that he made at the end of the 1870's. However, it was with pastels, which he also used for his monotypes, that he worked the most.

For the first portraits and landscapes he did in 1869, he preferred to use pastels in pure form, which, in the manner of Delacroix, he would spread lightly over smooth paper. Beginning in 1875, however, he experimented, for example, by mixing distemper with his pastels, then spraying the mixture with boiling water. He would then mix the result into a kind of paste that he would apply with a spatula or into a wash that he would apply with a stiff brush. Later, after Manet died, he moved closer to Impressionist techniques, creating through the use of colour instead of a brush, a "rainy effect" that gave his canvases the feeling of fabric. Or he would paint silk fans, building a composition with watercolours and touching up the figures with gold or silver. He exhibited some of these fans in 1879 at the fourth exhibition of the "Independents" (as the Impressionists called themselves, preferring that name to the one they were inevitably given). He continued to experiment, trying to imitate Italian frescoes and to rediscover flat tones using everything from distemper to gouache, and oil. But what interested him most was the problem of how to portray space. His subjects — arranged in a perfect composition in which the lines cut and divided the sheet into regular sections, each of which had been studied separately — came together harmoniously within the frame. Sometimes, to increase the feeling of depth, he enlarged some of his figures and architectural details and cut them laterally along the edge of the foreground. In his search for new depth, the ground or floor often played an important role. We have already looked at some paintings where this is apparent: *The Cotton Office, New Orleans* of 1873 and *Ballet Class* of the following year. But in *The Rehearsal* which he did in 1877, the dancers perform along the length of the axes of the diagonals. As usual, they are divided into groups according to what they are doing. The dancers, their tutus fluttering, are scattered over the oblique empty surface of the floor. The light shines on them, emphasizing the gracefulness of their movements. And yet as one admires these lovely dancers, there is no suggestion on the part of Degas of anything other than intellectual interest in the portrayal. The dance, that is, the concept of the dance, is explored in all of its aspects: above all as a craft, as work, as a discipline, but it is also looked at as a routine with its everyday tasks. Degas did not allow anything of the idealised female in his paintings, something he had always made clearly understood, even going so far as to write of the women of New Orleans that they "were almost all pretty and many had among their charms that touch of ugliness without which there is salvation." This intransigence regarding the idealisation of feminine beauty, which often stood in the way of what Degas searched for, is evident. So although he often painted women nude, Degas portrayed them with no particular emphasis on that aspect nor with any morbidity about it, and he photographed them in natural poses doing things that were comfortable and familiar to them.

Certainly Degas loved to study and observe women: he was seduced by what they did and how they did it, by their motions and their expressions. He noted in one of his notebooks, "Think about a treatise on adornments for women or by women, of the way they observe and combine things, the way they get dressed. Much more than men, they compare a thousand things to each other every day."

An indefatigable perfectionist with an insatiable curiosity about life, Degas did not overlook sculpture. When he was still an adolescent he was attracted to that art to the point that at the beginning of his career he wondered whether he should become a painter or a sculptor. Among his early works, we should note his horses, done before 1870, followed immediately by his dancers, whose three-dimensional study offered him the opportunity to analyse deeply volume and proportion. His *Little Dancer, Aged Fourteen*, for example, a bronze statue of a girl wearing a toile bodice and a tulle tutu and caught in a dancer's pose, dates from 1880.

Renoir said of Degas's sculptures: "Since Chartres, there is only one sculptor and that is Degas. The one who did the cathedrals was able to give the idea of eternity. That was the great preoccupation of that age. Degas has found the means to express the sickness of our contemporaries, or I should say, the movement. We are fidgety, and Degas' horses and gentlemen are fidgety."

Edouard Manet died in 1883, just two years before Degas painted his *Race Horses* with its simple strokes and energetic yellows full of light. Manet's death was a great loss to Degas, even if their relationship had always been somewhat strained, because of their very different ways of looking at painting. They had known each other for over twenty years. Degas had a difficult and somewhat intolerant nature, he allowed no one to come near him while he was working and even though he was capable of ending a friendship he held dear over a difference of opinion (as he did regarding the Dreyfus case), Degas had always held on to his friendship.

He was an extraordinarily uncompromising man, above all with regard to himself, both in his work and in his private life. For example, he never wanted to show any of his work until in 1892, when thanks to Durand-Ruel, he agreed to exhibit 26 "imaginary landscapes", some of which had been executed when he had travelled to Burgundy with the sculptor Bartholomé.

On the eve of the twentieth century his forms were growing full of light and colours such as yellow, pink, orange and blue, while the lines of the drawings were growing fainter. The modernity of his paintings won him the enthusiasm of young artists. They nicknamed him "the dancers' painter", but they loved him for the spirit of freedom emanating from his works, as well as for the works themselves. Among his admirers were Toulouse-Lautrec, Bonnard, Maurice Denis, Suzanne Valadon, and Edouard Vuillard who would remain his disciple for as long as he could. The last years of his life were not happy ones however. Like the strong paints Degas had spread on his canvases, his eyesight was fading and growing blurred.

By the time he died at the age of 83, he was blind. So let us remember him instead the way he was described by his friend Paul Lafond, with "a high wide rounded forehead, crowned with silky chestnut-brown hair, lively, shrewd, questioning eyes, shadowed by a high arched brow in the form of a circumflex accent mark, with a fine clever mouth under a soft beard."

1. The Duke and Duchess of Morbilli - 1867. The Museum of Fine Arts, Bequest of R. Treat Paine, Boston - *In this portrait of his sister and her Italian husband, Edmondo Morbilli, Degas has successfully brought out the character of his subjects, placing them against a light background.*

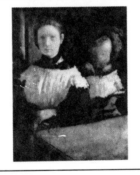

2. The Roman Beggar Woman - 1857. City Museum and Art Gallery, Birmingham, Alabama - *Following the example of the old masters, the artist has chosen a realistic style to create something which is both original and personal.*

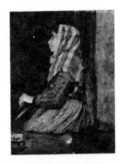

3. Jeanne and Julie Bellelli - about 1859. Gualino Collection, Rome - *Degas made many sketches of his young cousin Jeanne and eventually used them for his famous portrait of her family. This one, in which Julie, Jeanne's sister, is only sketched in at the far right, is the most finished.*

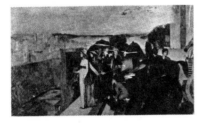

4. Semiramis Founding a Town - 1861. Musée du Louvre, Paris - *The neo-classical influence on Degas is apparent in this unfinished work, which is one of a series of five historical paintings.*

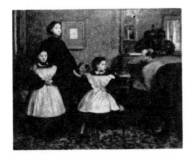

5. The Bellelli Family - 1860-62. Musée d'Orsay, Paris - *The art of portraiture is expressed in an innovative way in this family grouping. In his own words, Degas wanted "to paint portraits of people in typical and familiar settings and especially to give their faces the same range of expression that one would give to their bodies."*

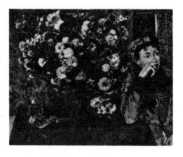

6. A Woman with Chrysanthemums - 1865. H.O. Havemayer Collection, The Metropolitan Museum of Art, New York - *This portrait, with its typical Degas lines, places the woman in a life-like setting and allows her natural expression to come through.*

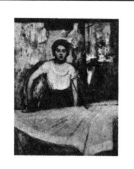

7. Woman Ironing - 1869. Bayerische Staatsgemälde-sammlungen, Munich - *Degas was in the habit of doing many sketches before completing his final work. This unfinished canvas is an example of the stages he passed through from the conception of an idea to the finished painting.*

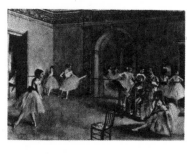

8. Ballet Rehearsal Room at the Opéra - 1872. Musée du Louvre, Paris - *Degas found an endless source of inspiration in the world of the dance. Here it is translated into a delicate play of golden and silver light to which he adds warm ochre shadows.*

9. By the Seaside - 1869. Musee du Louvre, Cabinet des Dessins (cliché des Musées Nationaux), Paris - *In 1869, Degas spent many hours doing sketches of the seashore. His pastel tones beautifully reproduce the watery atmosphere and salty flavour of the French coast.*

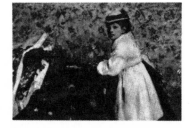

10. Portrait of Hortense Valpinçon (detail) - 1869. Minneapolis Institute of Arts - *Paul Valpinçon was a close friend of Degas. His father, Edouard Valpinçon, had introduced the young artist to Ingres. During one of his visits with the Valpinçon family, Degas painted Hortense, Paul's daughter, choosing for the portrait vivid colours that give the painting a feeling of spontaneity.*

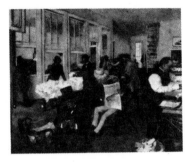

11. The Cotton Office, New Orleans - 1873. Musée des Beaux-Arts, Pau - *Degas has brought together his family and friends in the confused and hectic atmosphere of a cotton office. His uncle Musson is examining some samples of cotton, his brother René is reading a newspaper, his other brother Achille is leaning against a window and the cashier John Levandais is going over the accounts.*

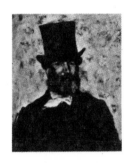

12. Portrait of Léopold Levert - 1874. Private collection, USA - *Fascinated by people and the world they lived in, Degas would return to portraiture throughout his career.*

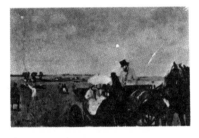

13. Carriage at the Races - 1870-73. Museum of Fine Arts, Boston - *The colour and movement of the horse races inspired Degas as much as the world of dance. This study, a masterly portrayal of the long-lined elegant horses and the world of racing is one of the best of its kind.*

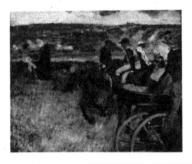

14. At the Races (detail) - about 1872. Musée du Louvre, Paris - *Degas began to paint scenes from the races even before his friend Manet. In this composition, he played with perspective and asymmetry in subtle ways to accentuate the movement of the horses.*

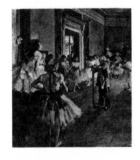

15. Ballet Class - 1874. Musée d'Orsay, Paris - *Degas began to go regularly to ballet and other classes at the Opéra beginning in 1873. After spending hours observing the dancers and making endless sketches of them, he would then go back to his studio to paint what he had seen.*

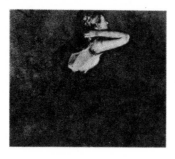

16. Seated Dancer with her Hand on her Neck - 1874. Musée du Louvre, Cabinet des Dessins (cliché des Musées Nationaux), Paris - *Ballet inspired Degas to study movement. One result of his studies can be seen in this brown wash on dark brown paper.*

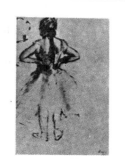

17. Dancer Seen from Behind - 1876. Musée du Louvre, Cabinet des Dessins (cliché des Musées Nationaux), Paris - *This is an india ink and gouache study on glossy pink paper. It was probably a preparation for one of his many works that took the dance class as a motif.*

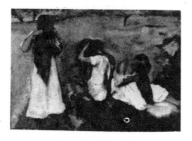

18. Girls Combing their Hair - 1875-76. Phillips Collection, Washington, D.C. - *In this oil on oiled paper, the light colour of the oil mixed with the oil of the paper is completely different from the heavy intense effect of pastels. Through these subtle variations on the same theme, we can see how technique can give energy to the image.*

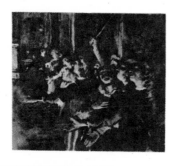

19. The Chorus - 1877. Musée du Louvre, Cabinet des Dessins (cliché des Musées Nationaux), Paris - *In many of Degas's works, light plays a crucial role. In this pastel the marked contrast between the zones in shadow and the bright colours creates an almost unreal effect, giving the faces the appearance of masks.*

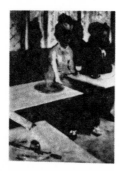

20. Absinthe - 1876. Musee d'Orsay, Paris - *In its clear use of perspective, this famous painting reveals the influence of Japanese art on Degas. The oblique lines of the table seem to anticipate some of his most masterly works of the future.*

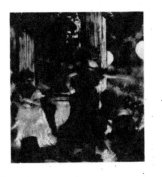

21. The Café-concert at Les Ambassadeurs - 1876-77. Musée des Beaux-Arts, Lyon - *This is one of Degas's most charming interpretations of Parisian theatre life. Degas first prepared a monotype which he later finished in pastels. The luminous colours of the pastels culminated in the figure of the singer.*

22. Cabaret - 1876. W.A. Clark Collection, The Corcoran Gallery of Art, Washington, D.C. - *The clear contrasts, the diagonal lines of the scene, the movements caught as if by surprise and fixed as in a photograph, all combine to make this pastel a masterpiece of visual aesthetic vitality.*

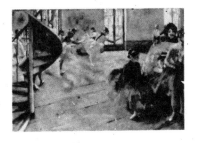

23. The Rehearsal - 1877. The Burrell Collection, Art Gallery and Museum, Glasgow - *When Degas painted his first rehearsal room in 1872, he painted it in the classic style, but later he adopted the Impressionist technique with its diffused vibrant light. This use of light along with the position of the moving figures is what gives the work its vitality.*

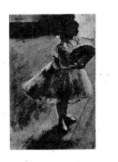

24. Dancer with Fan - 1879. Private collection - *This work, a combination of various materials such as distemper, watercolours and oils, was the result of many attempts by the artist, who was always looking for new techniques.*

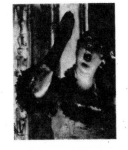

25. Singer with a Glove - 1878. The Fogg Art Museum, Bequest of Maurice Wertheim, Harvard University, Cambridge, Mass. - *The manner in which the face is illuminated gives this pastel its vivacity. It is emphasised by the strong contrast between black and white that the limelights produce and by the intensity of singer's gesture.*

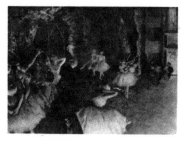

26. Rehearsal on the Stage (detail) - about 1873. The Metropolitan Museum of Art, Havemayer Collection, New York - *Degas moved rapidly from studies of dance classes to rehearsals. In this painting he was able to capture the graceful plies of the dancers. Note the way the artist has lit up the orchestra from behind.*

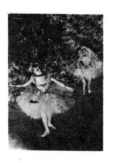

27. Dancers on Stage - 1880. Private collection - *While experimenting with different techniques, Degas explored the motif of the dance in countless ways. In this distemper and pastel painting, the mixture allowed him to create a surprising effect of lighting.*

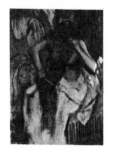

28. Woman Combing her Hair - 1887-90. Musée du Louvre, Paris - *The female nude held a particular attraction for Degas. This work is another example of that interest and of his efforts to capture movement, which can be seen in the purity of the curved lines.*

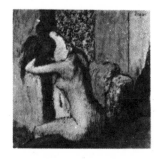

29. Woman Drying her Neck - 1898. Musée du Louvre, Cabinet des Dessins, Paris - *In this painting with its greenish tones, the model seems to have been caught by surprise at a private moment.*

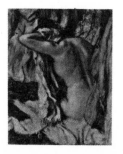

30. After the Bath - 1885. Private collection - *The many women portrayed at intimate moments are examples of the sensitivity of the artist, who captured in their gestures and movements, an expression of the quality of their life.*

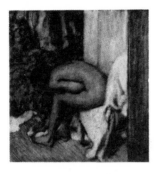

31. Woman Drying her Feet - 1886. Musée du Louvre, Paris - *One of Degas's favourite themes, that of women caught during an intimate moment, owes much to the traditional nudes of the Renaissance and to Impressionism and painters like Renoir. The tension of the lines is accentuated and softened by the sensual use of colour.*

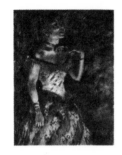

32. The Singer in Green - 1884. The Metropolitan Museum of Art, Havemayer Collection, New York - *The unexpected linear perspective, the position of the model and the play of light and shadow combine here to create an interesting mixture of fantasy and reality.*

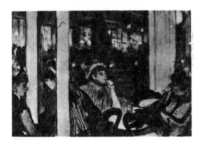

33. Women at the Terrace of a Café - 1877. Musée du Louvre, Cabinet des Dessins, Paris - *Women were the favourite subject of Degas who considered them symbols of the modern world. They never ceased to stimulate the curiosity of the painter and to be an inspiration to him.*

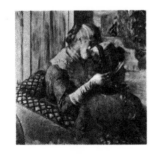

34. At the Milliner's - 1885. Private collection, USA - *With his acute powers of observation, Degas was able to capture the images of daily life in all their freshness. It was with women in particular that he found an infinite number of nuances and expressions.*

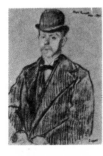

35. Portrait of Alexis Rouart - 1895. Private collection, USA - *Degas was always very meticulous, both in his paintings and in the quick sketches he did for his friends, one of which is this example executed in pastels.*

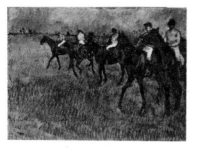

36. Jockeys in the Rain - 1881. Art Gallery and Museum, Glasgow - *This pastel shows the originality with which Degas often reworked his outdoor scenes. By putting different planes and perspectives in relief he reached a harmonious balance.*

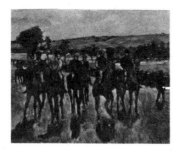

37. The Start of the Race - 1885. *Movement is the true protagonist in this composition. Degas caught the energy of the horses at a precise moment during the race and fixed this image on canvas.*

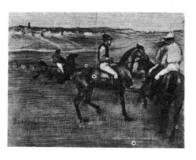

38. Race Horses - 1885. Private collection - *This pastel brings out a particular characteristic of Degas - his ability to create a three-dimensional illusion whereby the foreground seems closer and the background seems farther away. He achieved this by playing with the figures and their placement.*

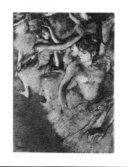

39. A Corner of the Stage during the Ballet - 1883. Private collection, USA - *The richness and the imagination of the ballet fascinated Degas. The wonderful world of costumes, light, and the magic of the stage had a special charm for him.*

40. Dancer Tying her Shoes - 1880. Private collection, USA - *Degas was not an artist who painted "art for art's sake". He always attempted to give life, personality and dignity to his models, as well as the grace he felt they deserved.*

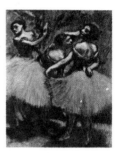

41. Three Dancers with Green Bodices - 1900. Private collection, USA - *Around 1900, as he worked on this pastel, his eyesight was growing weaker. His handicap seemed to stimulate him in his search for innovations as he pushed himself towards a greater freedom in his palette through the use of light.*

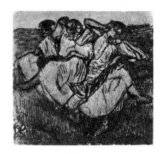

42. Three Russian Dancers - about 1895. National Museum, Stockholm - *This pastel is fresh proof of his constant search for new techniques, to the point that a simple sketch resembled the thick cloth of a garment.*

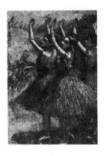

43. Three Dancers, Violet Skirts - 1898. Private Collection. *Degas often used the dancer motif to try out new techniques and new methods of expressing light and colours.*

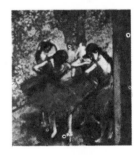

44. Blue Dancers - 1890. Musée du Louvre, Paris - *In the last years of his life, Degas was completely enthralled by the magic of colour. Its appeal for expressing movement and linear perspective assumed an all-encompassing importance. The human body eventually became simply a vehicle.*

1. *The Duke and Duchess of Morbilli* - 1867. The Museum of Fine Arts, Bequest of R. Treat Paine, Boston

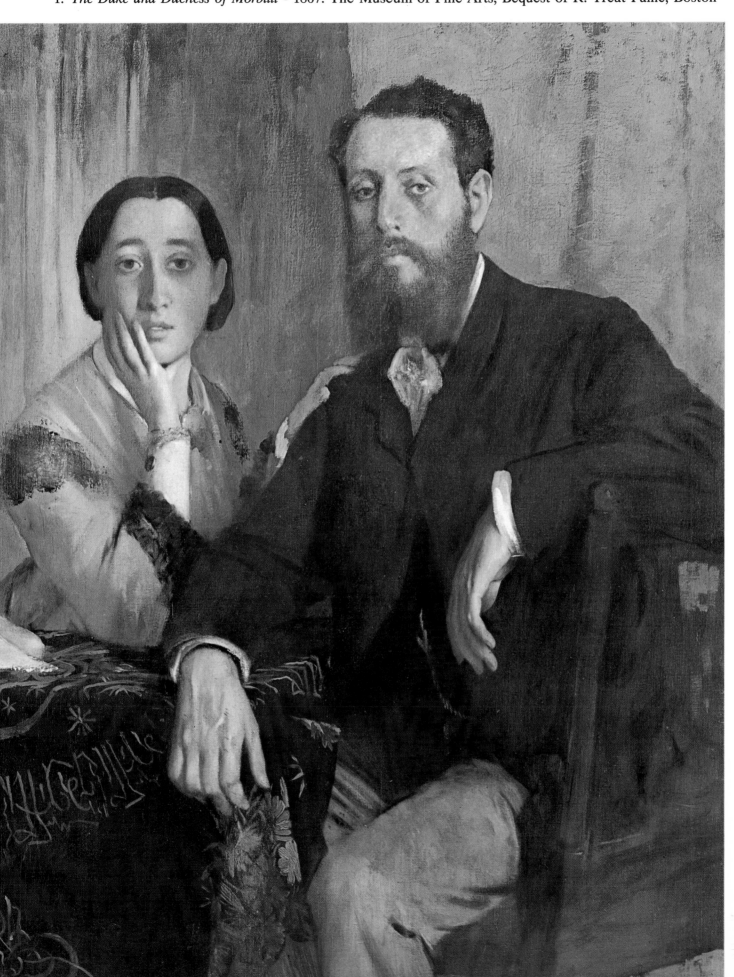

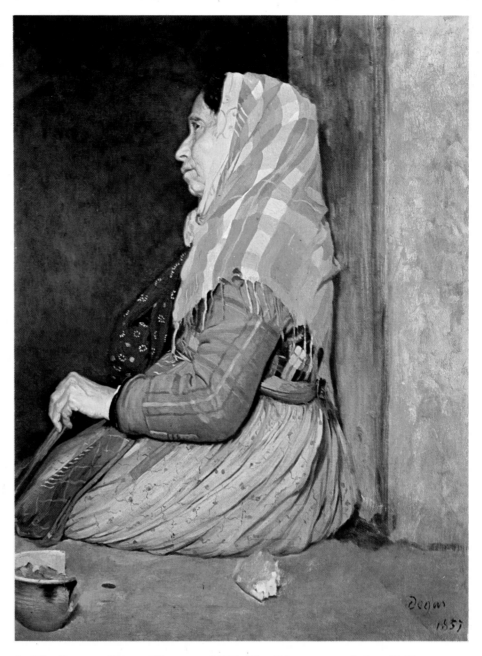

2. *The Roman Beggar Woman* - 1857. City Museum and Art Gallery, Birmingham, Alabama

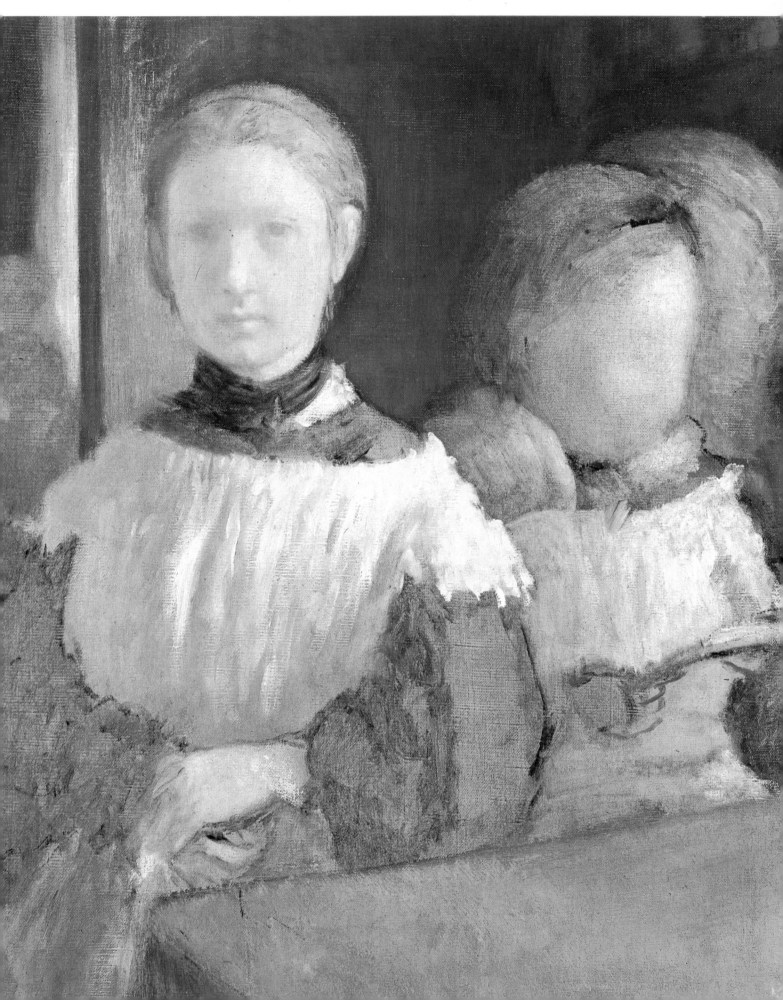

3. *Jeanne and Julie Bellelli* - about 1859. Gualino Collection, Rome

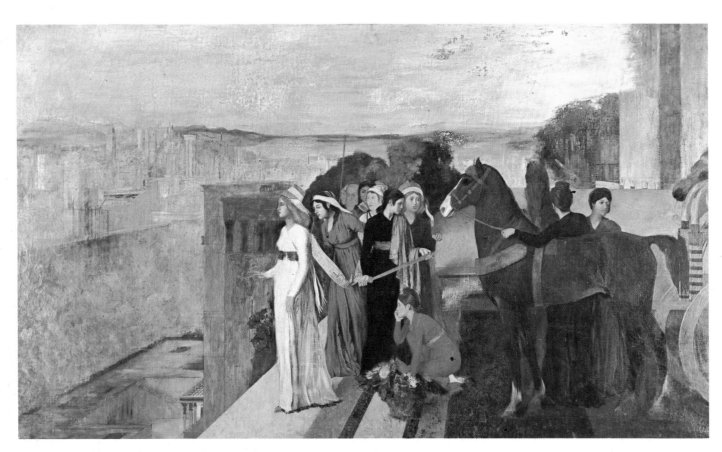

4. *Semiramis Founding a Town* - 1861. Musée du Louvre, Paris

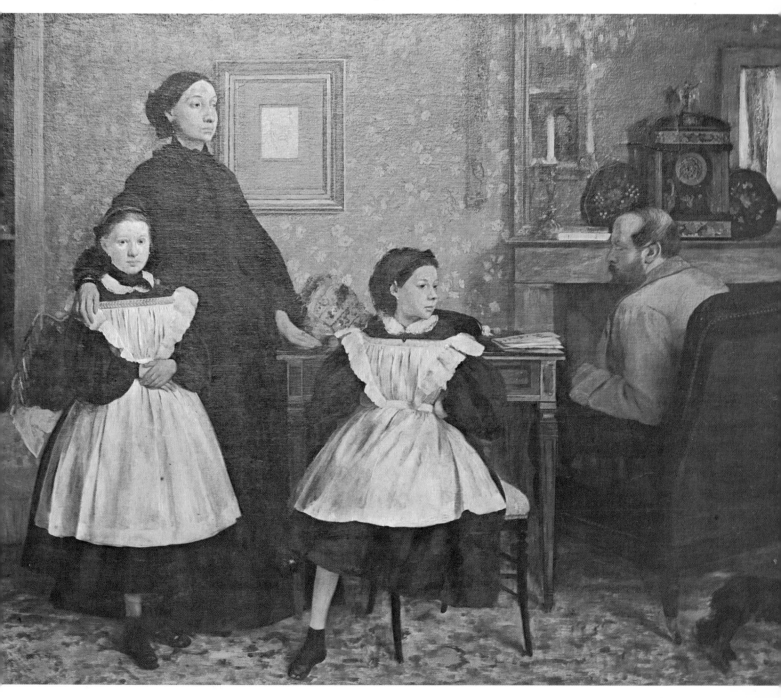

6. *A Woman with Chrysanthemums* - 1865. H.O. Havemayer Collection,
 The Metropolitan Museum of Art, New York

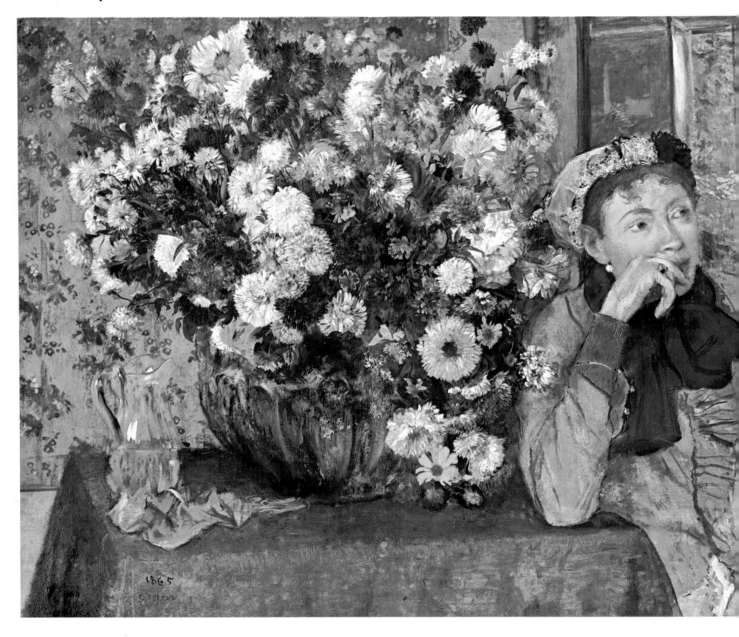

7. *Woman Ironing* - 1869. Bayerische Staatsgemäldesammlungen, Munich

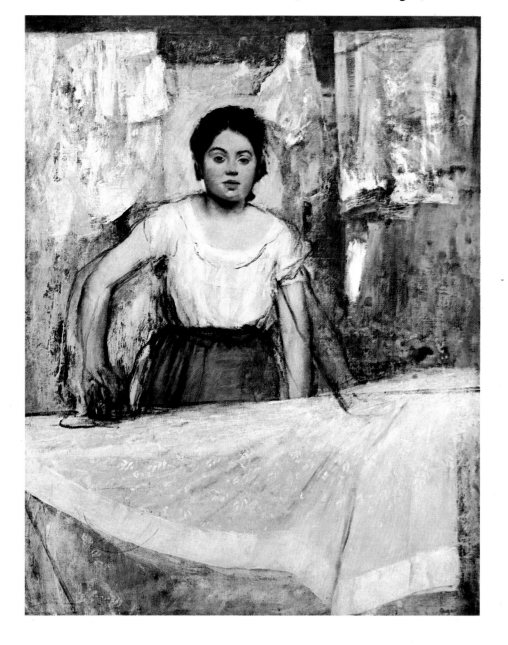

8. *Ballet Rehearsal Room at the Opéra* - 1872. Musée du Louvre, Paris

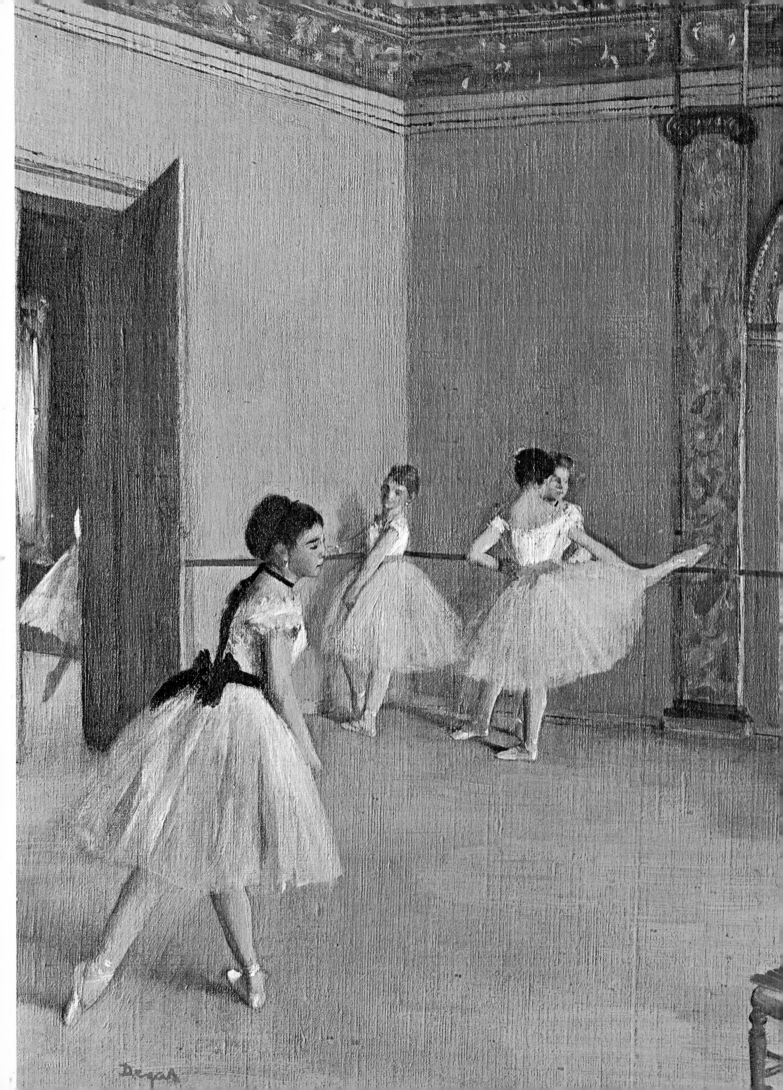

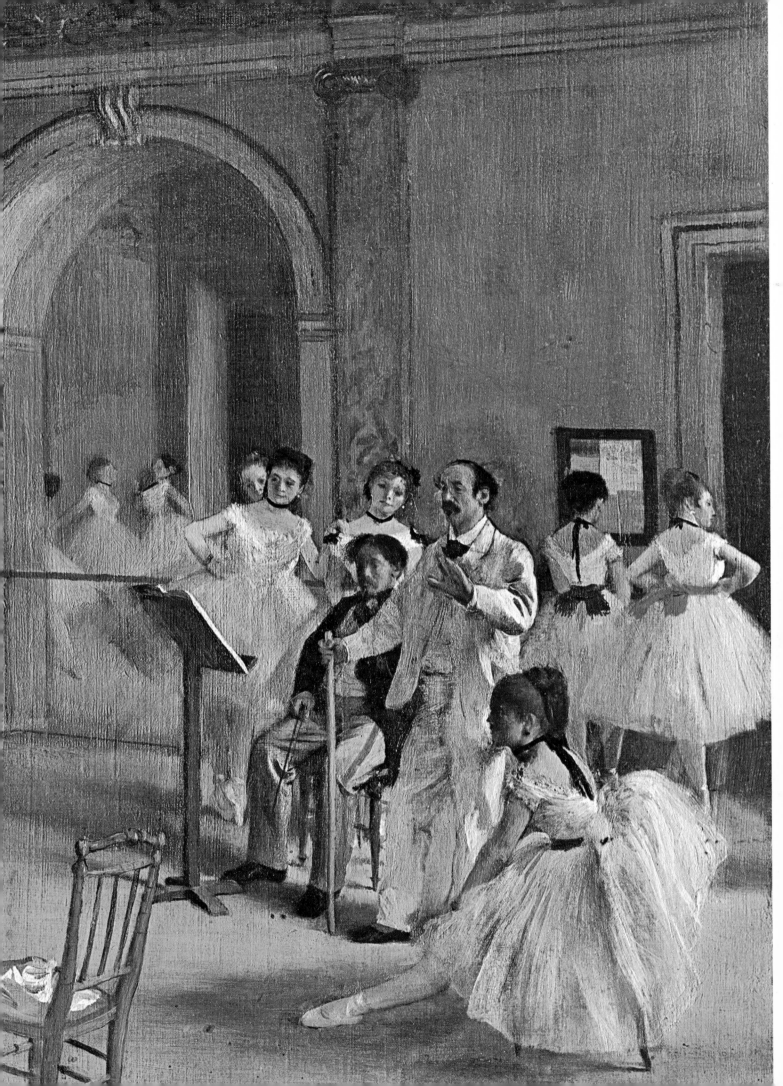

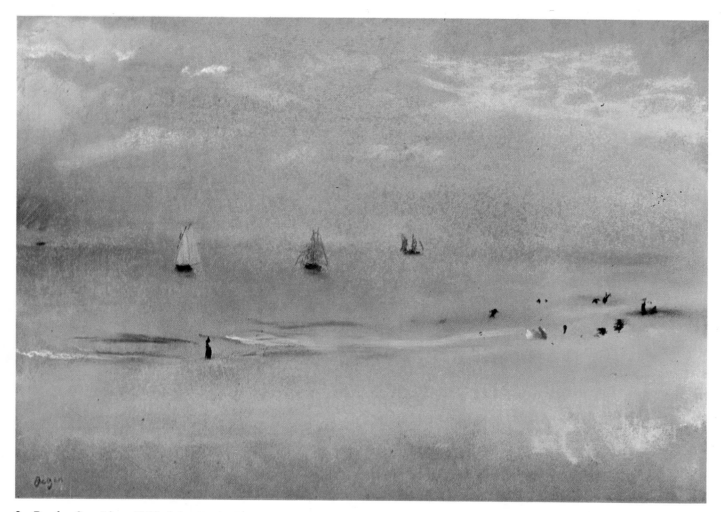

9. *By the Seaside* - 1869. Musée du Louvre, Cabinet des Dessins (cliché des Musées Nationaux), Paris

10. *Portrait of Hortense Valpinçon* (detail) - 1869. Minneapolis Institute of Arts

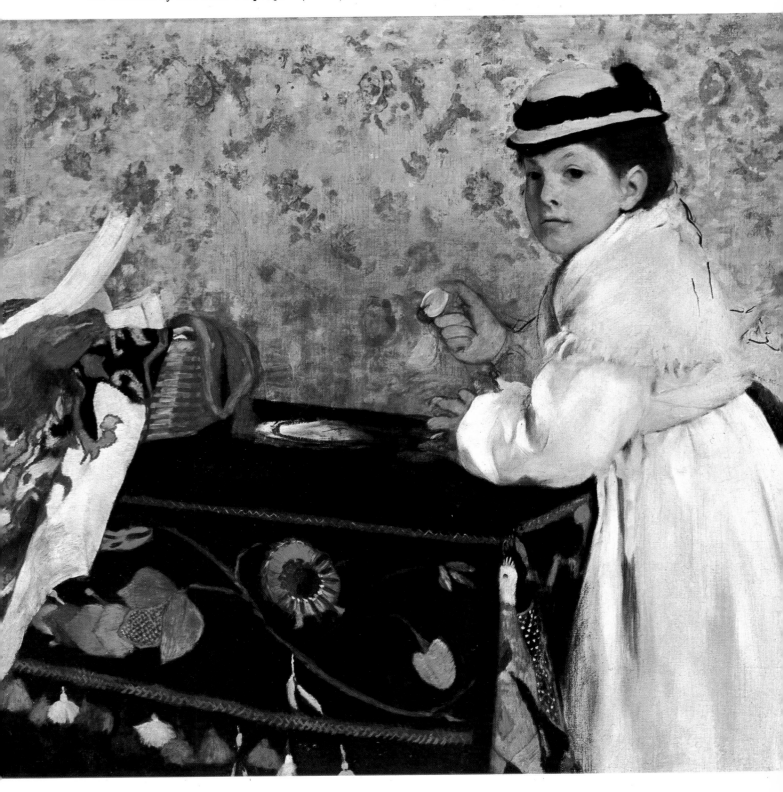

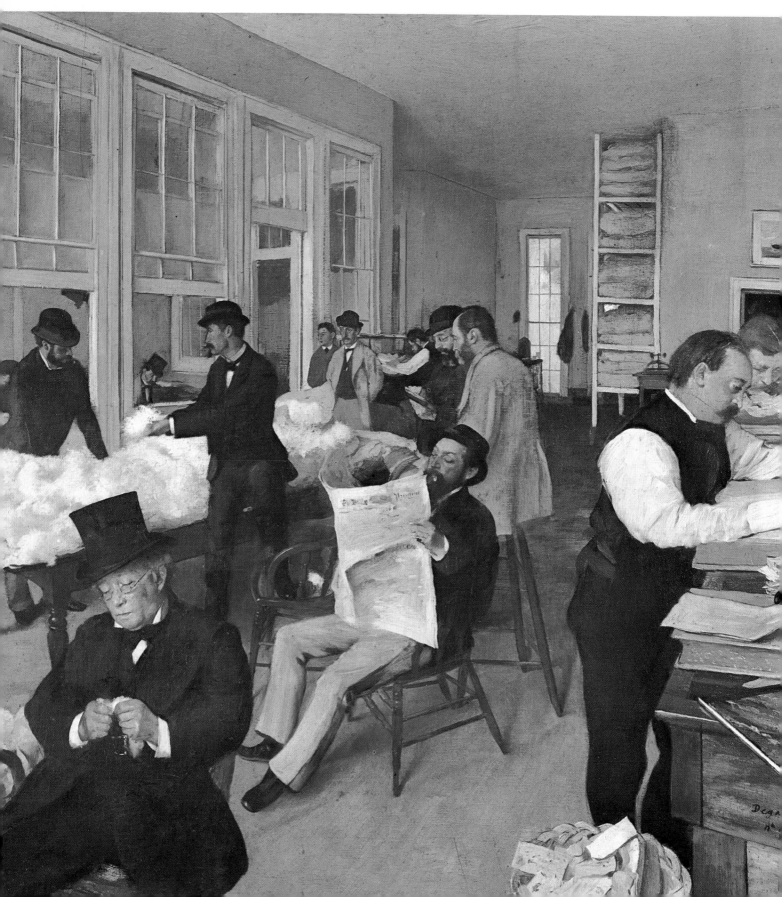

11. *The Cotton Office, New Orleans* - 1873. Musée des Beaux-Arts, Pau

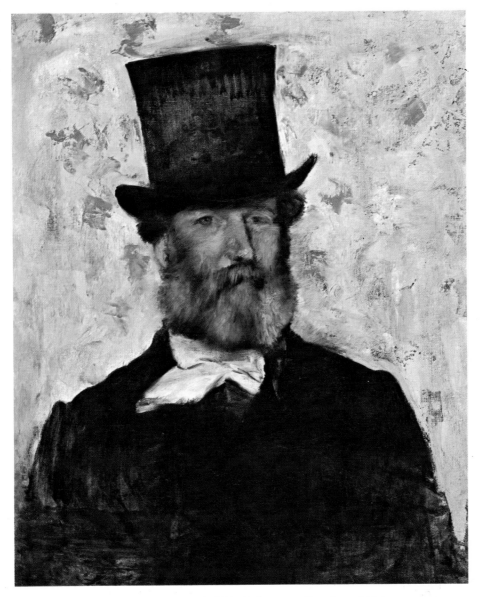

12. *Portrait of Léopold Levert* - 1874. Private collection, USA

13. *Carriage at the Races* - 1870-73. Museum of Fine Arts, Boston

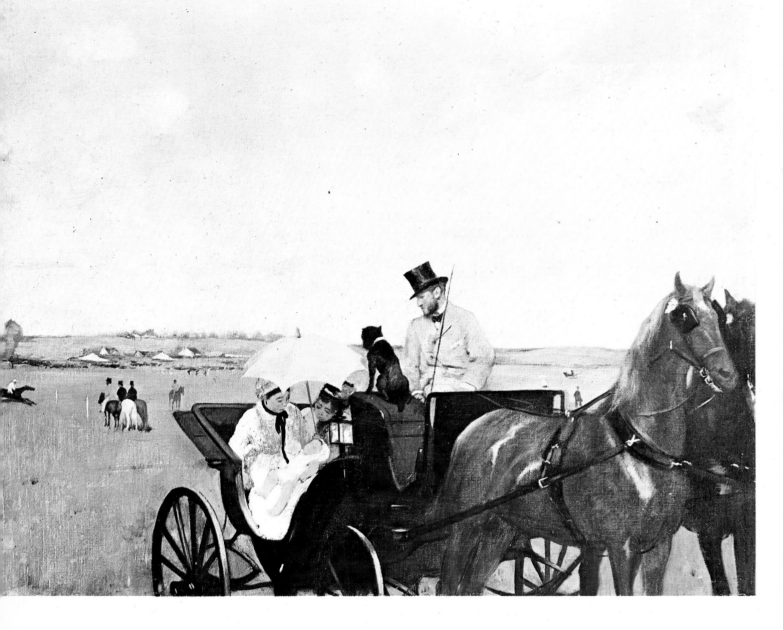

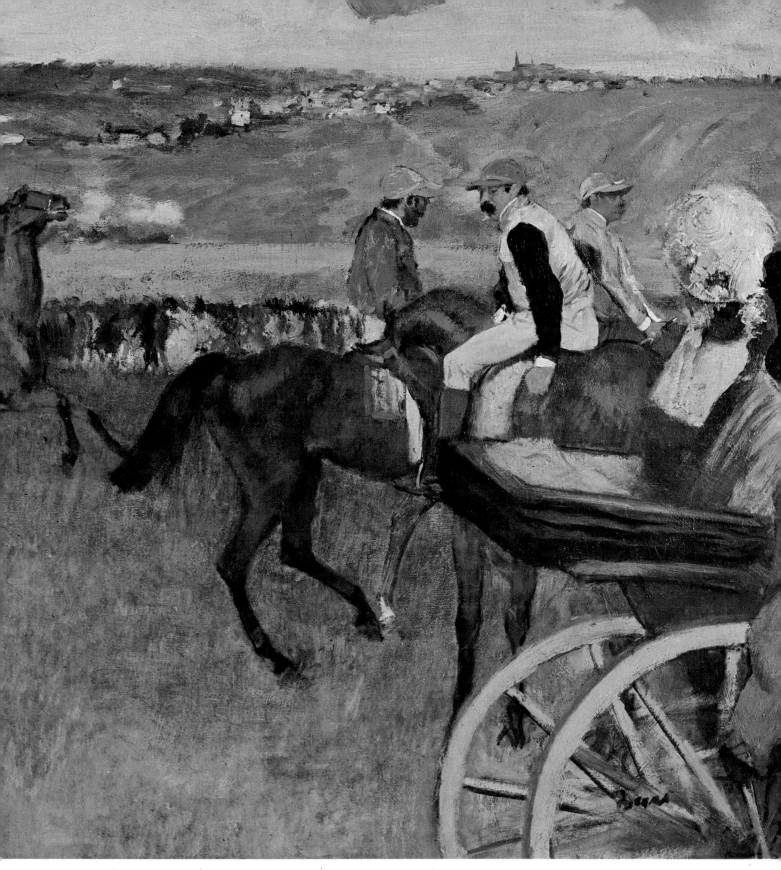

14. *At the Races* (detail) - about 1872. Musée du Louvre, Paris

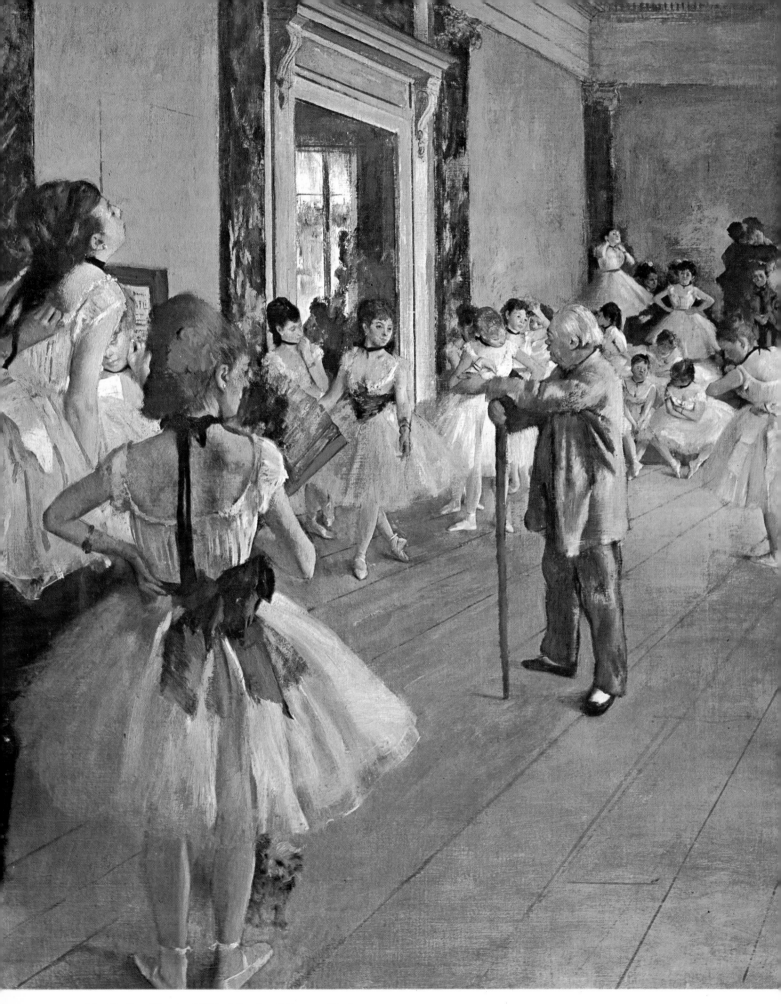

15. *Ballet Class* - 1874. Musée d'Orsay, Paris

16. *Seated Dancer with her Hand on her Neck* - 1874. Musée du Louvre, Cabinet des Dessins
(cliché des Musées Nationaux), Paris

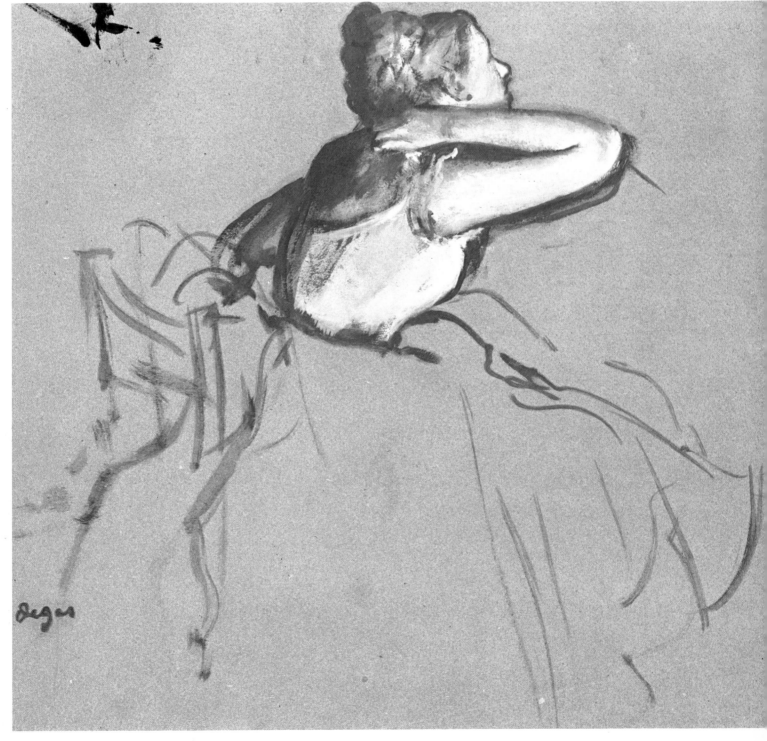

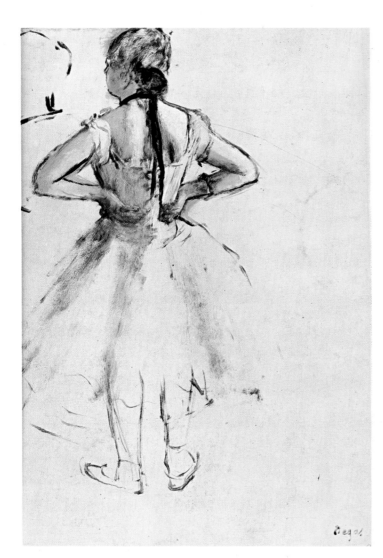

17. *Dancer Seen from Behind* - 1876. Musée du Louvre,
Cabinet des Dessins (cliché des Musées Nationaux),
Paris

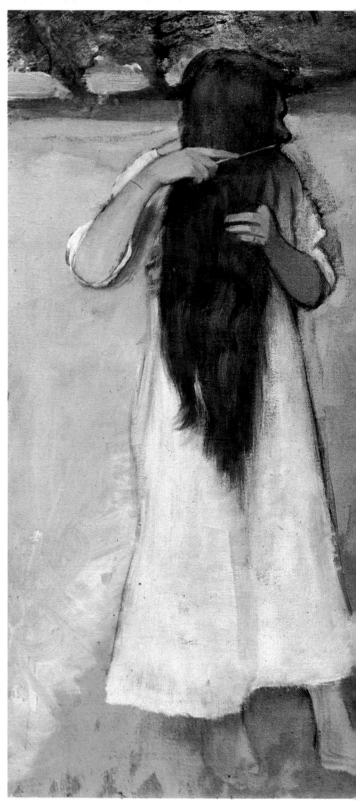

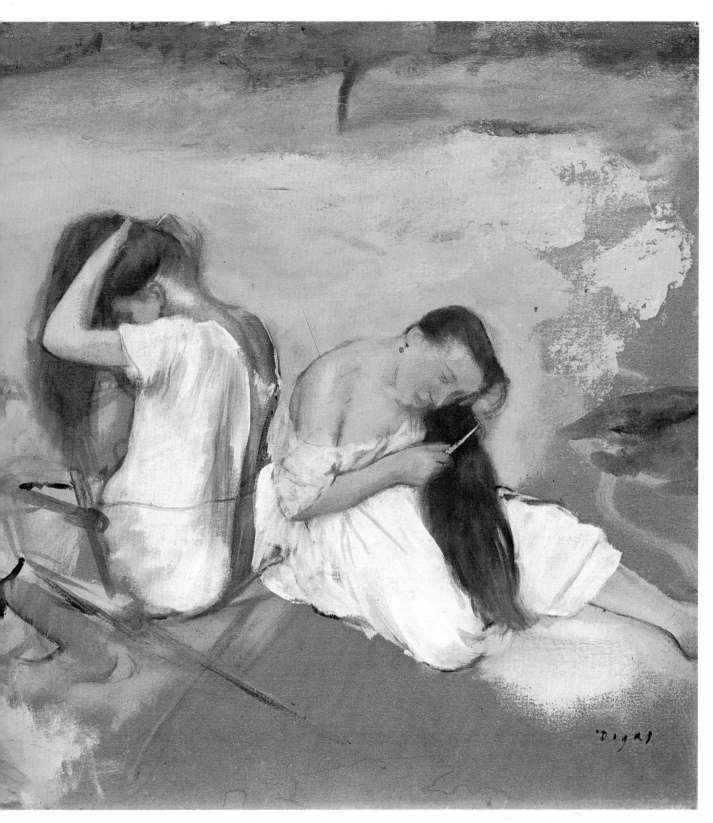

18. *Girls Combing their Hair* - 1875-76. Phillips Collection, Washington, D.C.

19. *The Chorus* - 1877. Musée du Louvre, Cabinet des Dessins
(cliché des Musées Nationaux), Paris

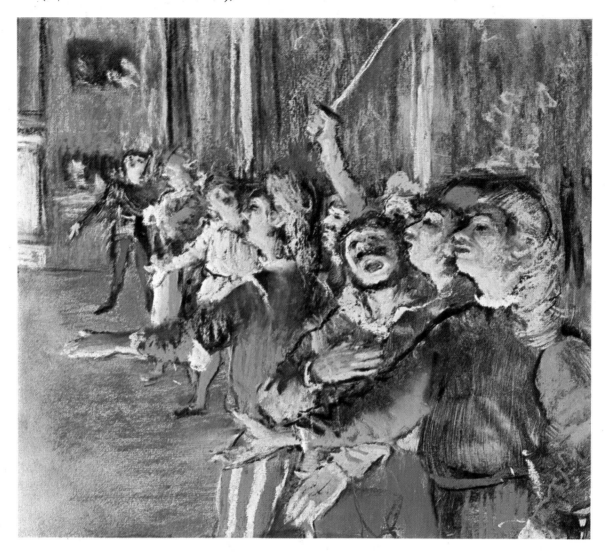

20. *Absinthe* - 1876. Musée d'Orsay, Paris

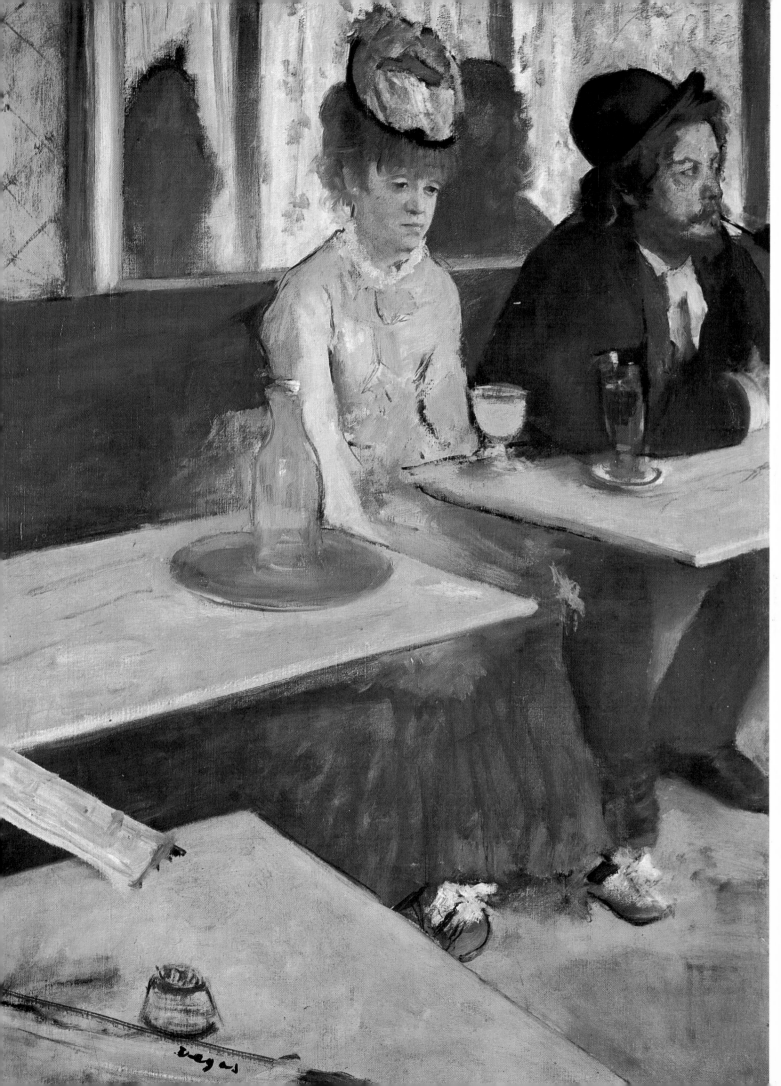

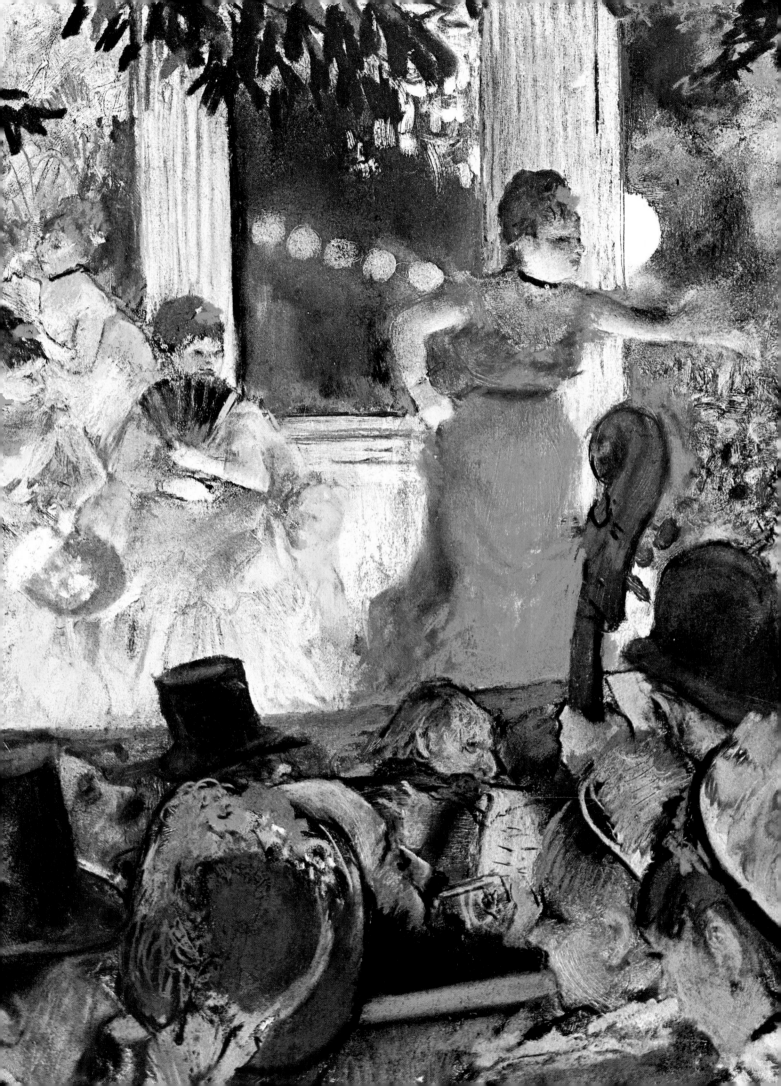

21. *The Café-concert at Les Ambassadeurs* - 1876-77.
Musée des Beaux-Arts, Lyon

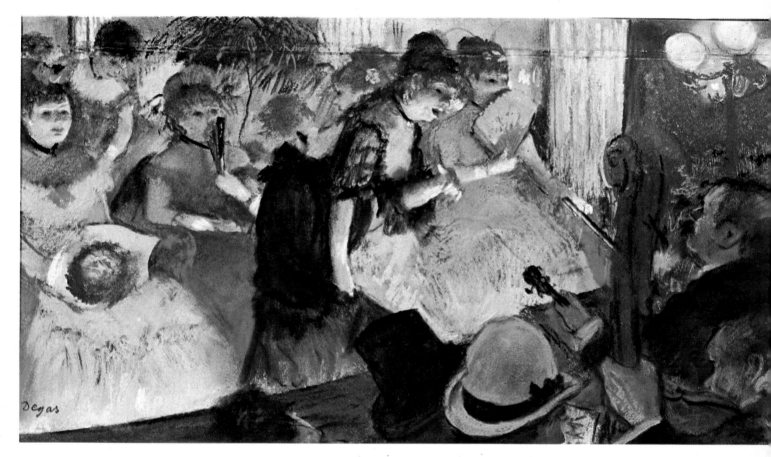

22. *Cabaret* - 1876. W.A. Clark Collection,
The Corcoran Gallery of Art, Washington, D.C

23. *The Rehearsal* - 1877. The Burrell Collection,
Art Gallery and Museum, Glasgow

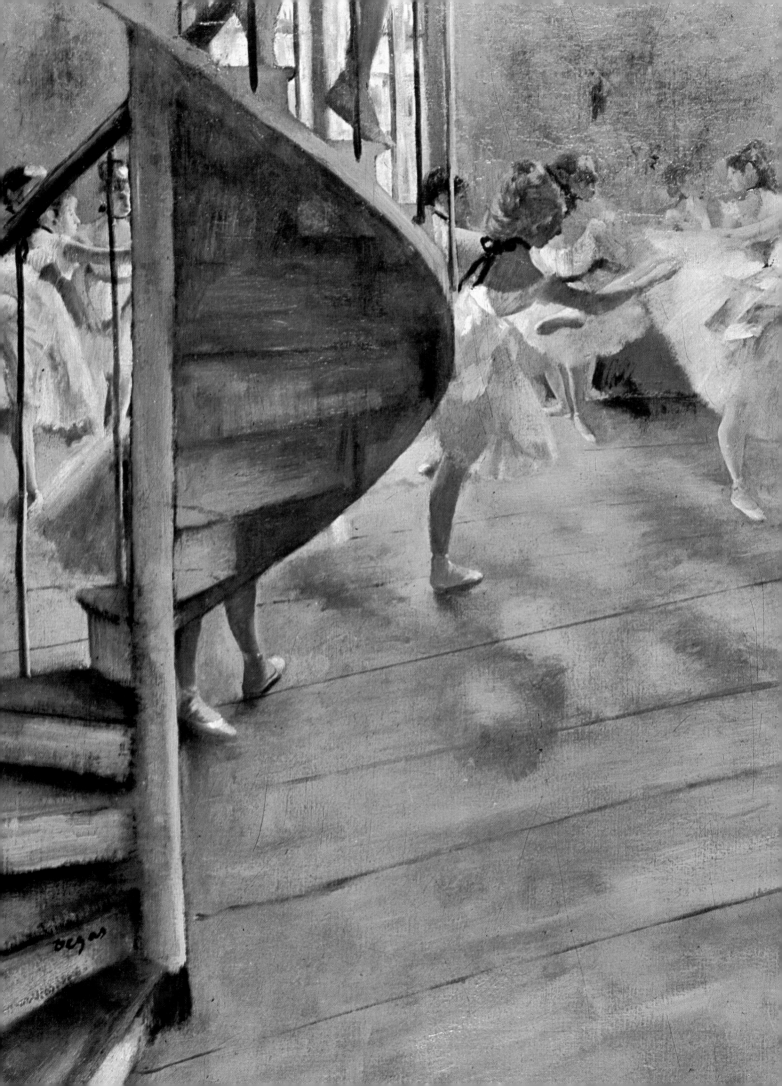

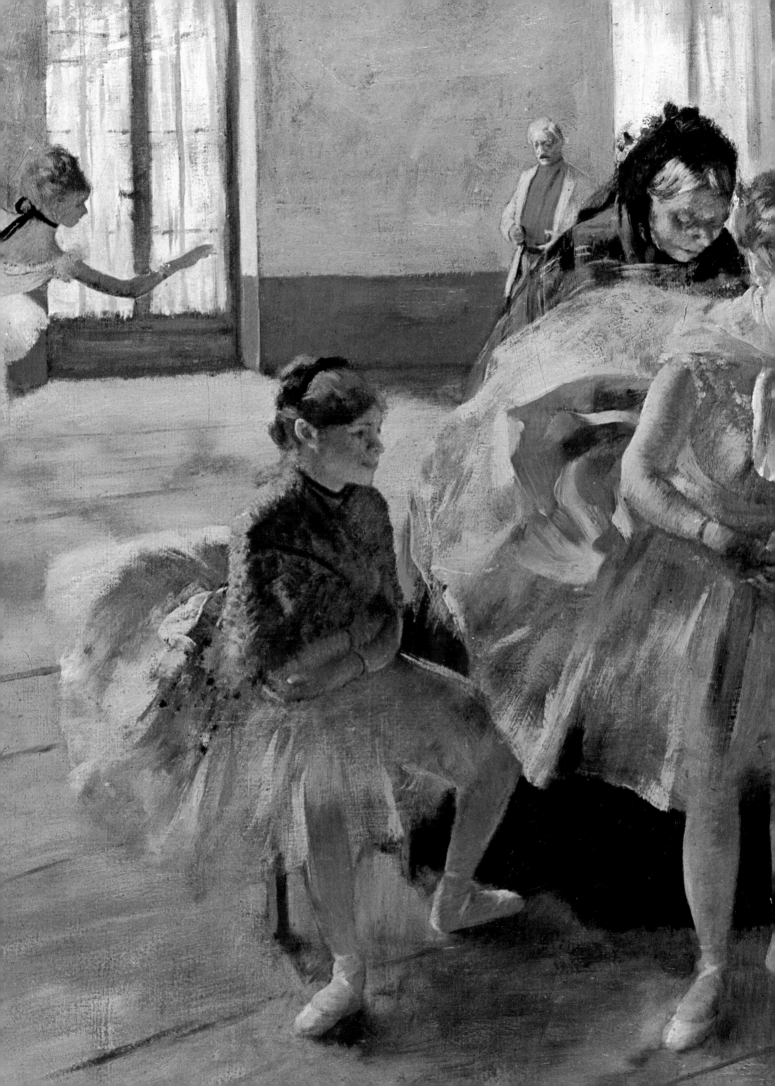

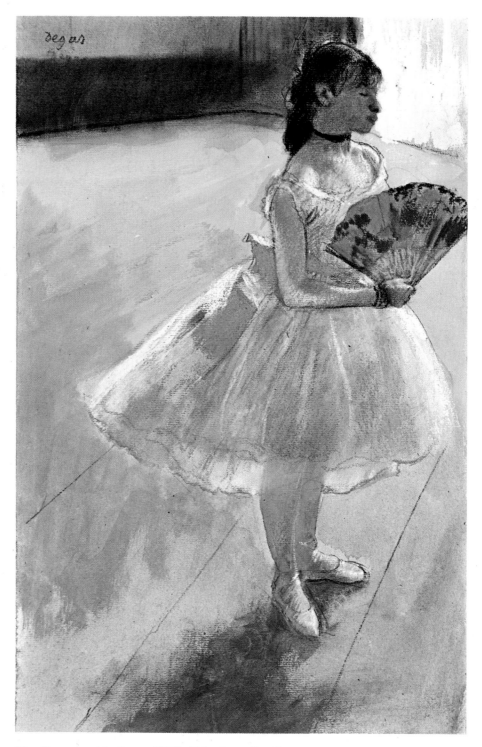

24. *Dancer with Fan* - 1879. Private collection

25. *Singer with a Glove* - 1878. The Fogg Art Museum, Bequest of Maurice Wertheim, Harvard University, Cambridge, Mass

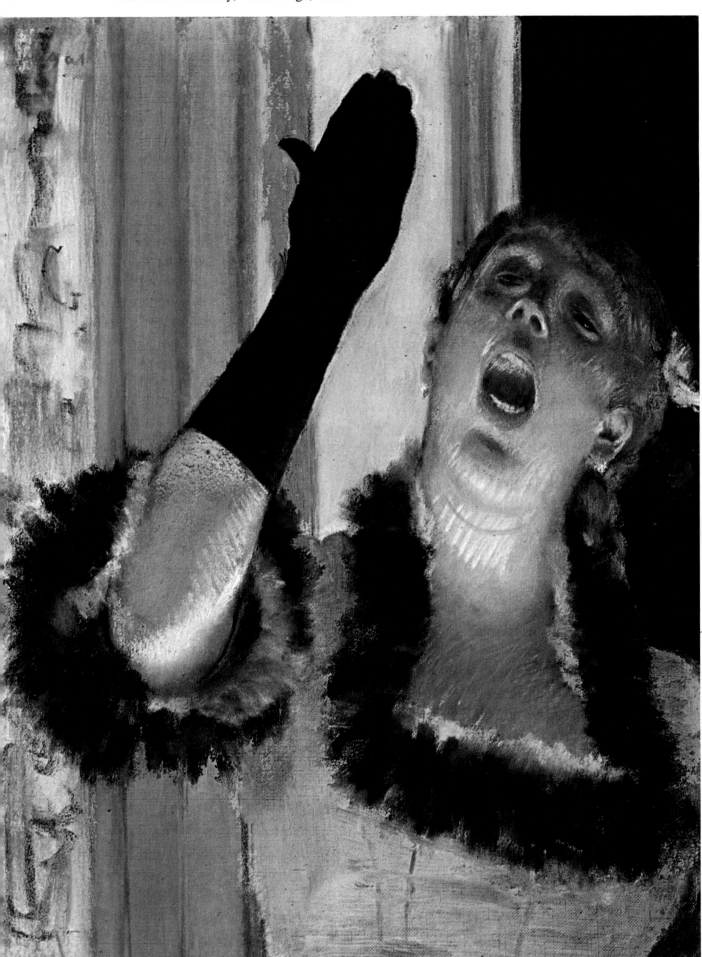

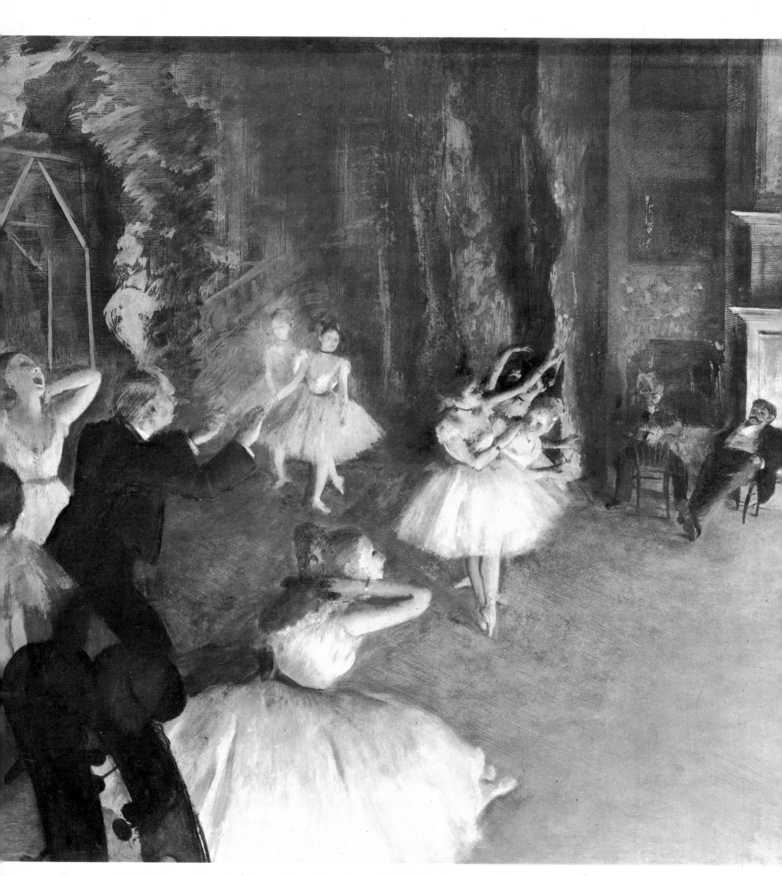

26. *Rehearsal on the Stage* (detail) - about 1873. The Metropolitan Museum of Art, Havemayer Collection, New York

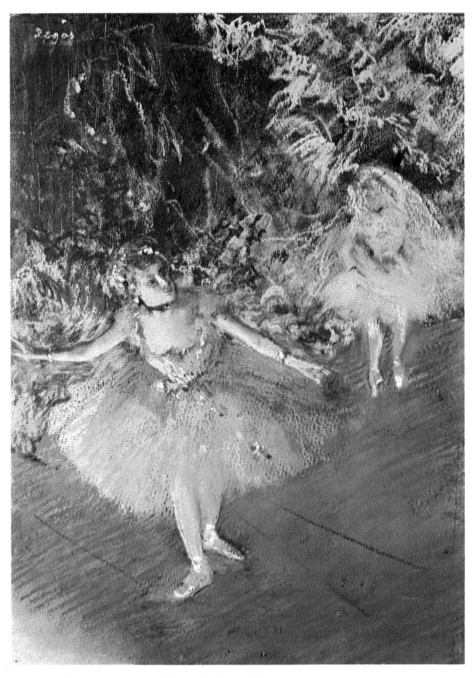

27. *Dancers on Stage* - 1880. Private collection

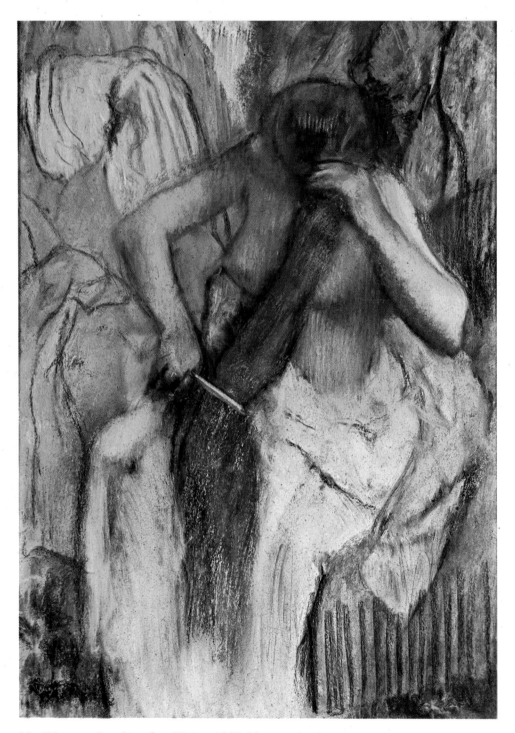

28. *Woman Combing her Hair* - 1887-90. Musée du Louvre, Paris

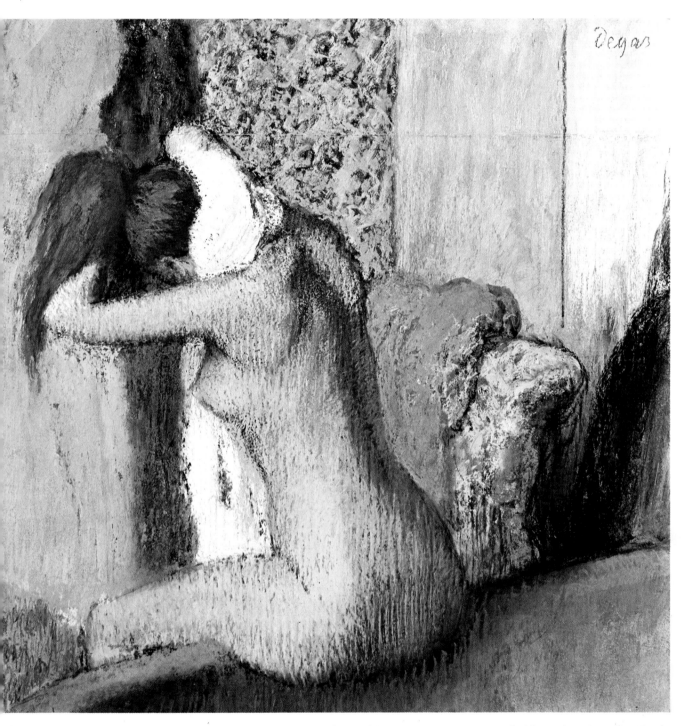

29. *Woman Drying her Neck* - 1898. Musée du Louvre, Cabinet des Dessins, Paris

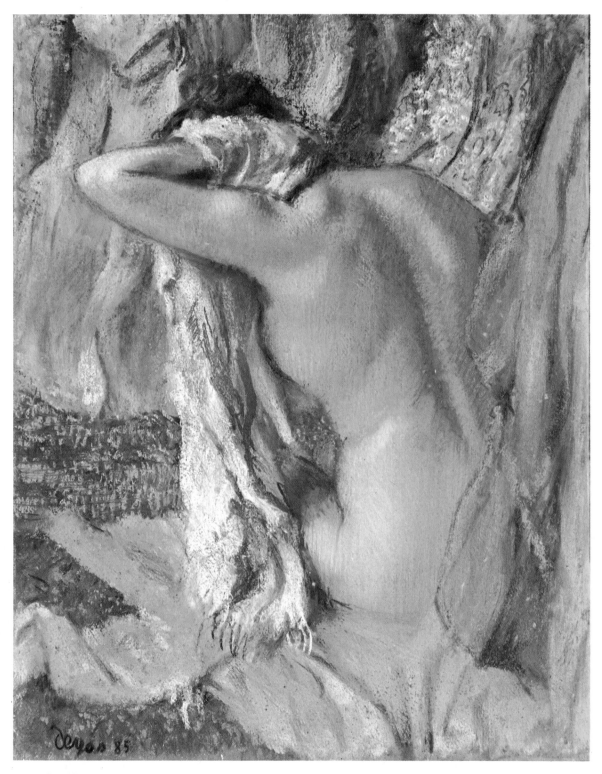

30. *After the Bath* - 1885. Private collection

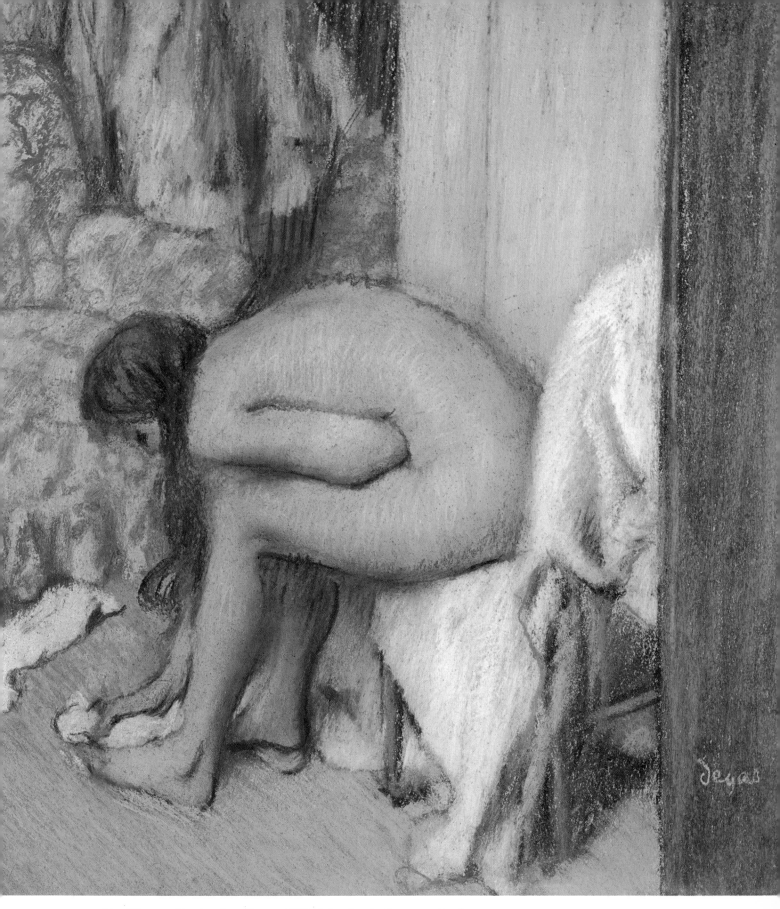

31. *Woman Drying her Feet* - 1886. Musée du Louvre, Paris

32. *The Singer in Green* - 1884. Havemayer Collection, The Metropolitan Museum of Art, New York

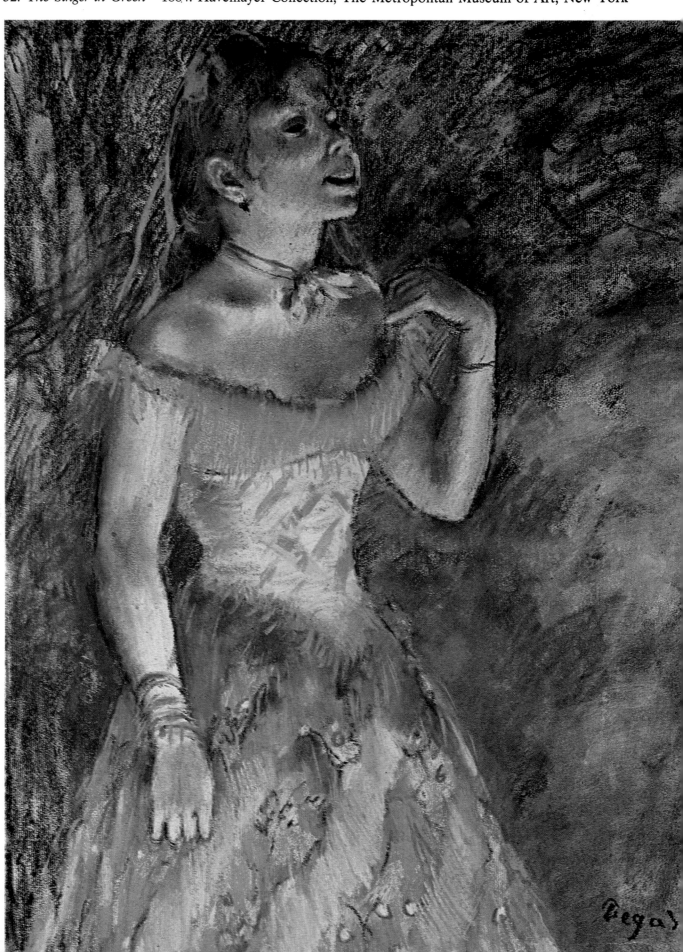

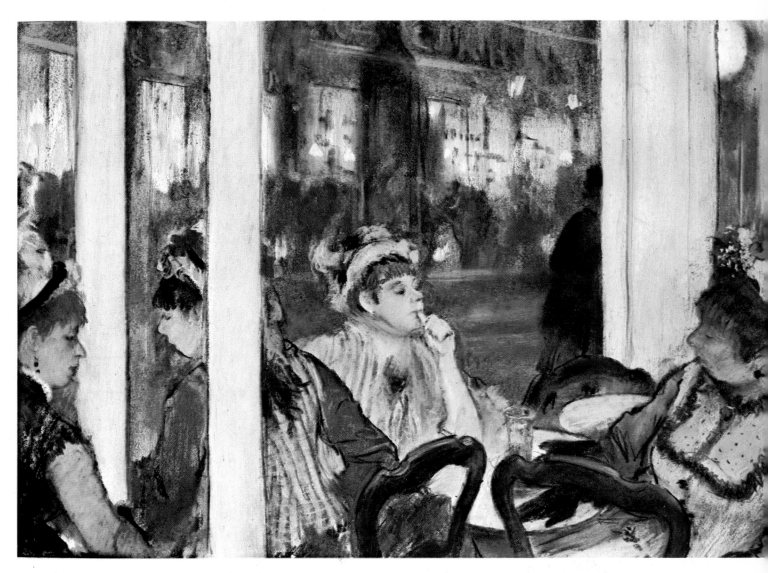

33. *Women at the Terrace of a Café* - 1877. Musée du Louvre, Cabinet des Dessins, Paris

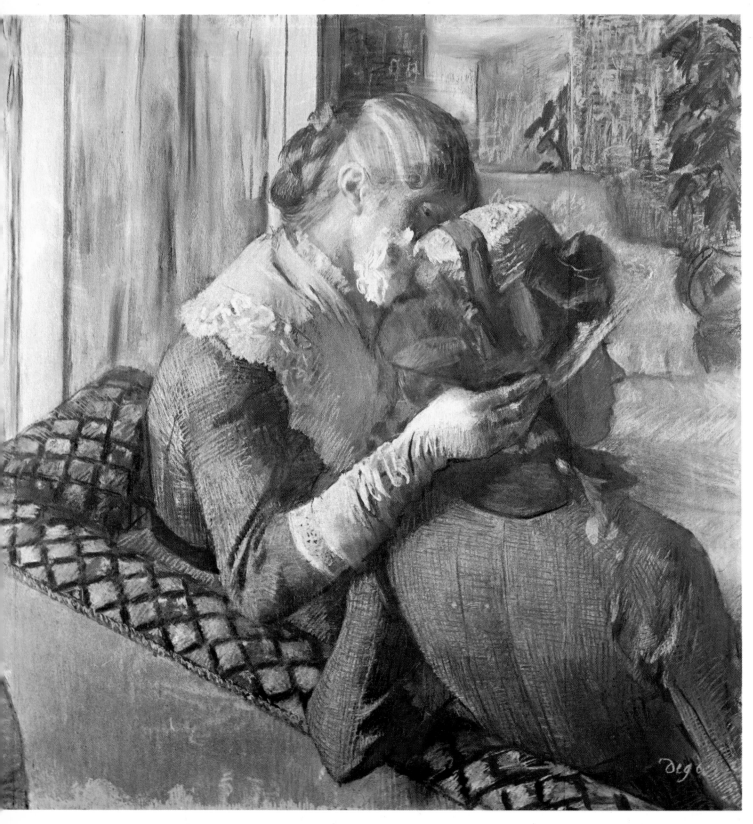

35. *Portrait of Alexis Rouart* - 1895. Private collection, USA

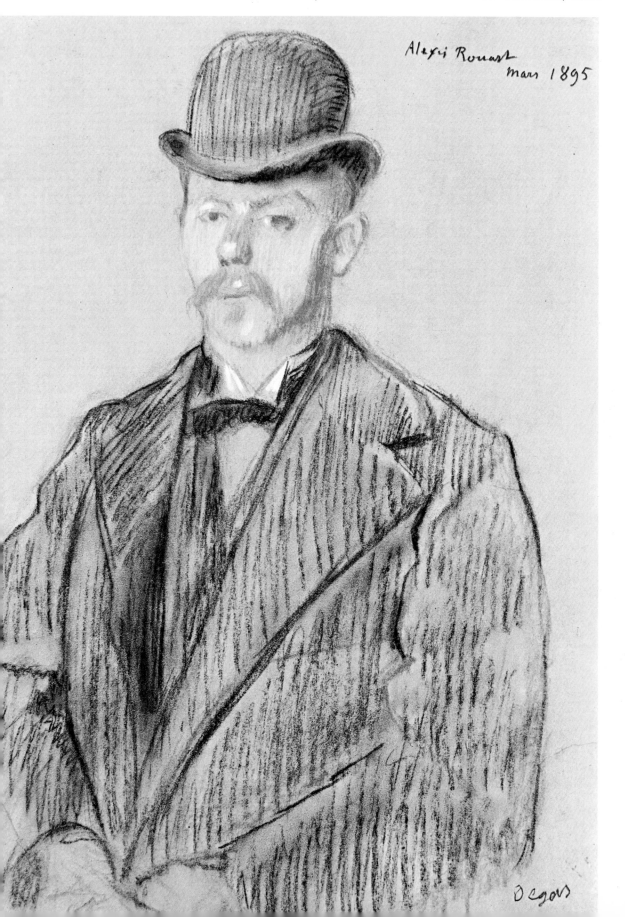

36. *Jockeys in the Rain* - 1881. Art Gallery and Museum, Glasgow

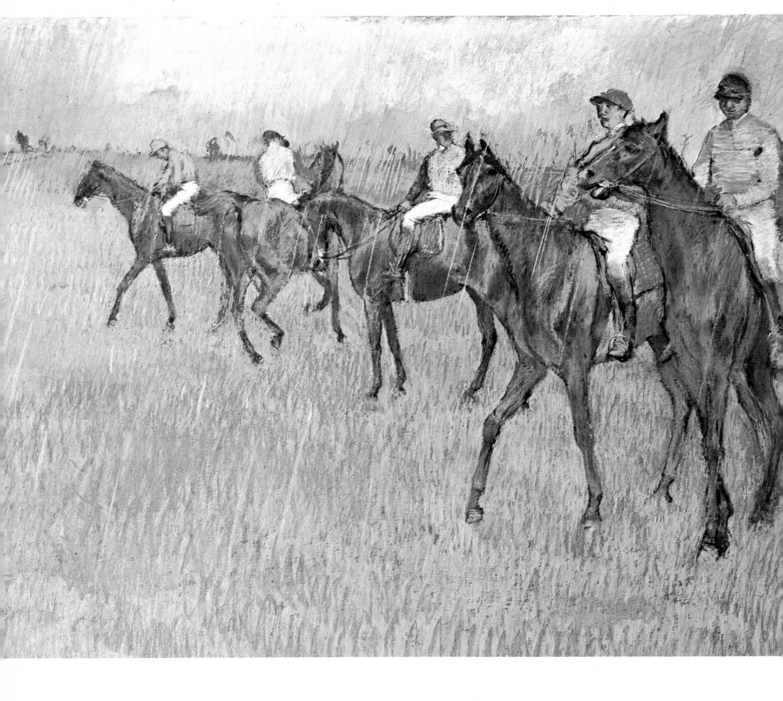

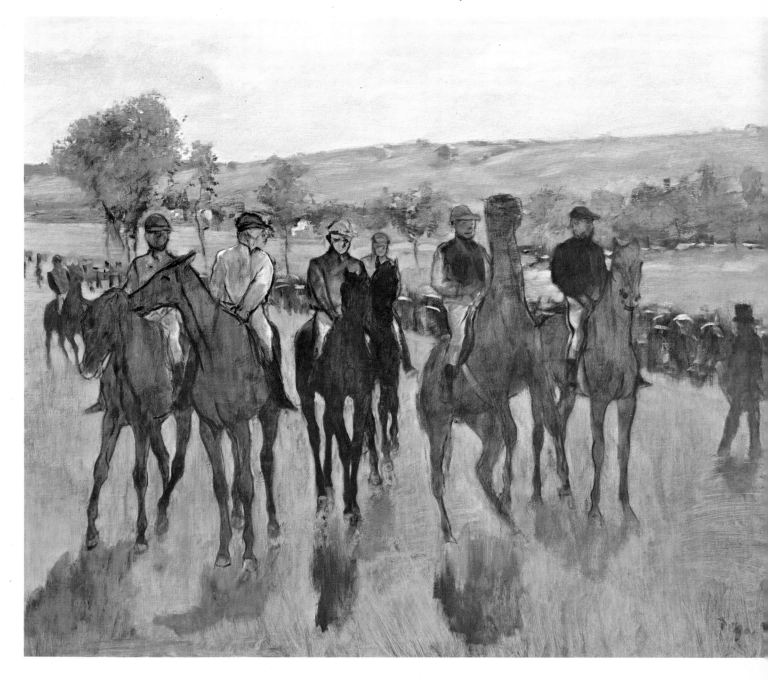

38. *Race Horses* - 1885. Private collection

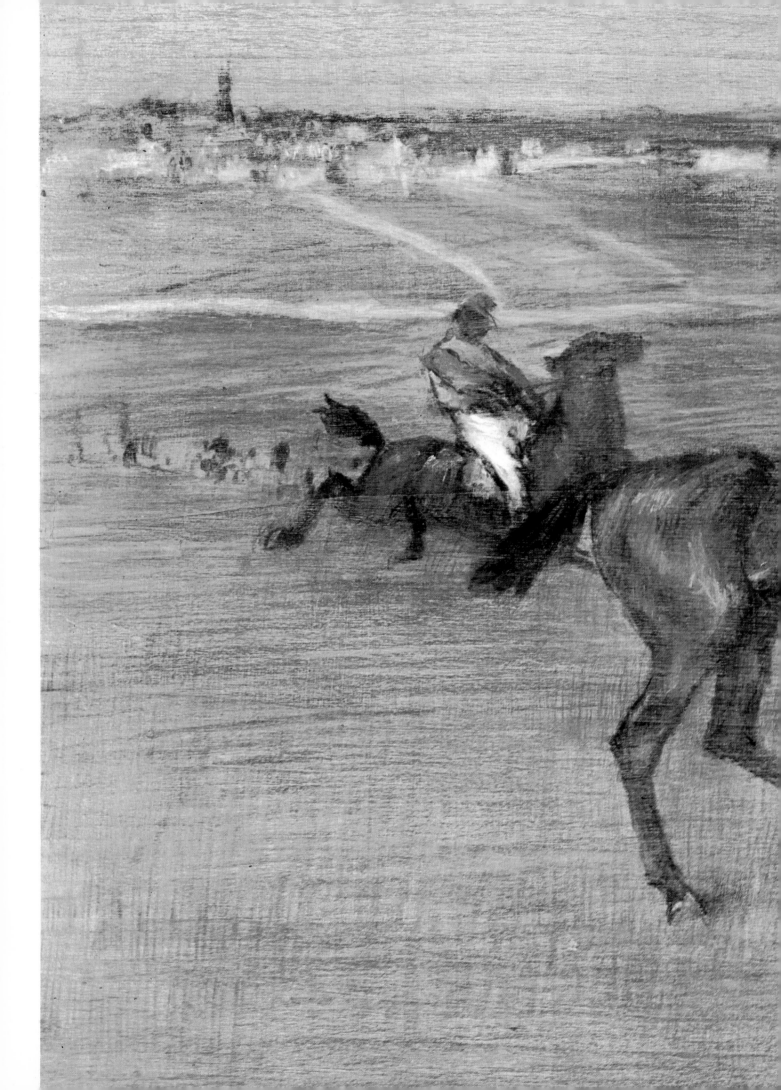

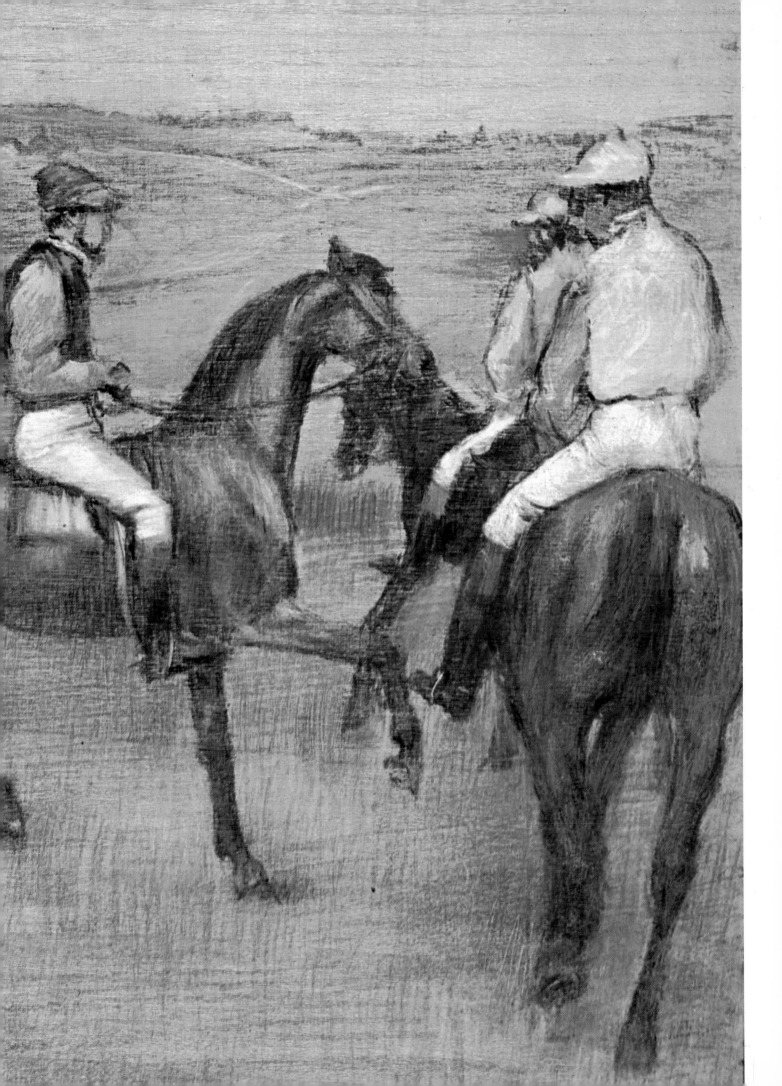

39. *A Corner of the Stage during the Ballet* - 1883. Private collection, USA

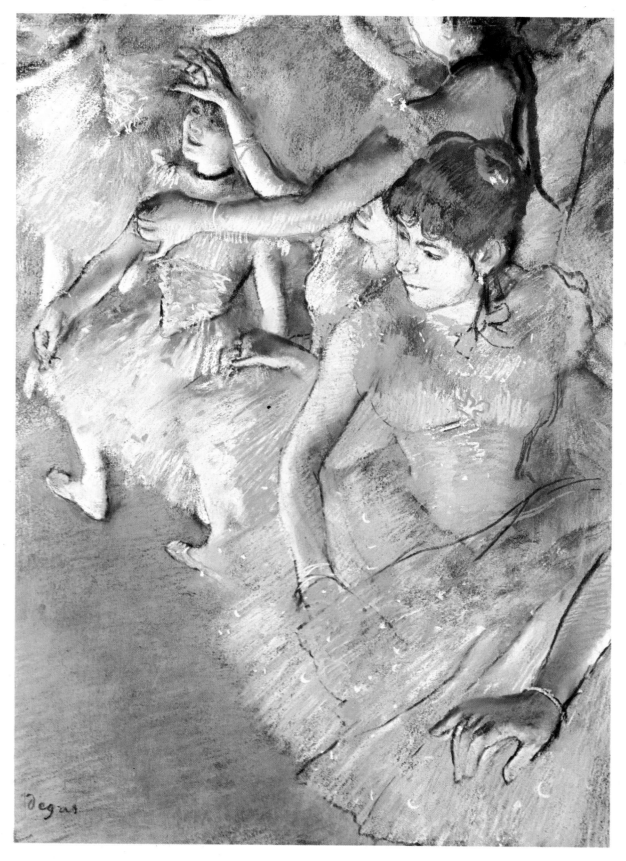

40. *Dancer Tying her Shoes* - 1880. Private collection, USA

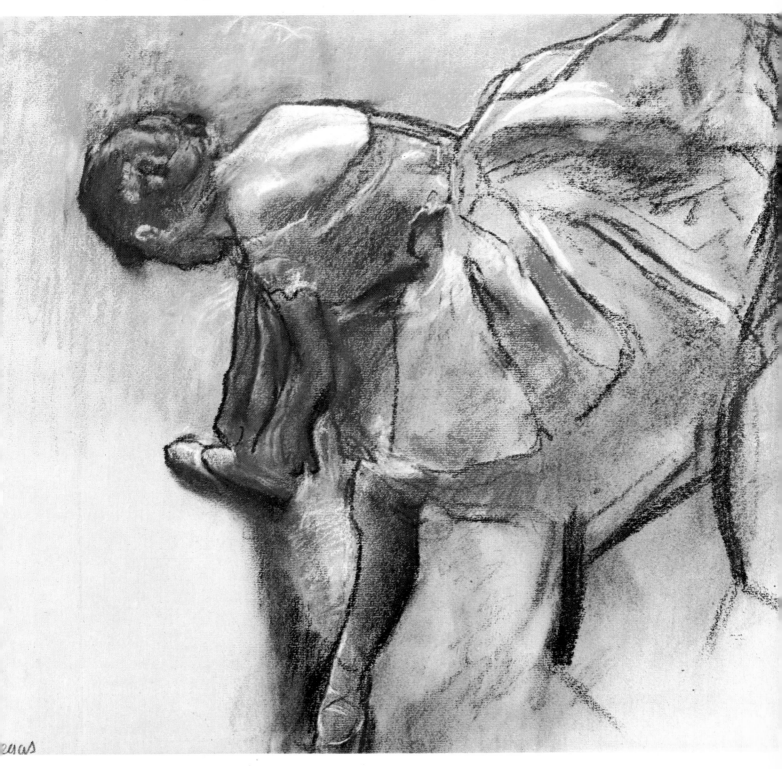

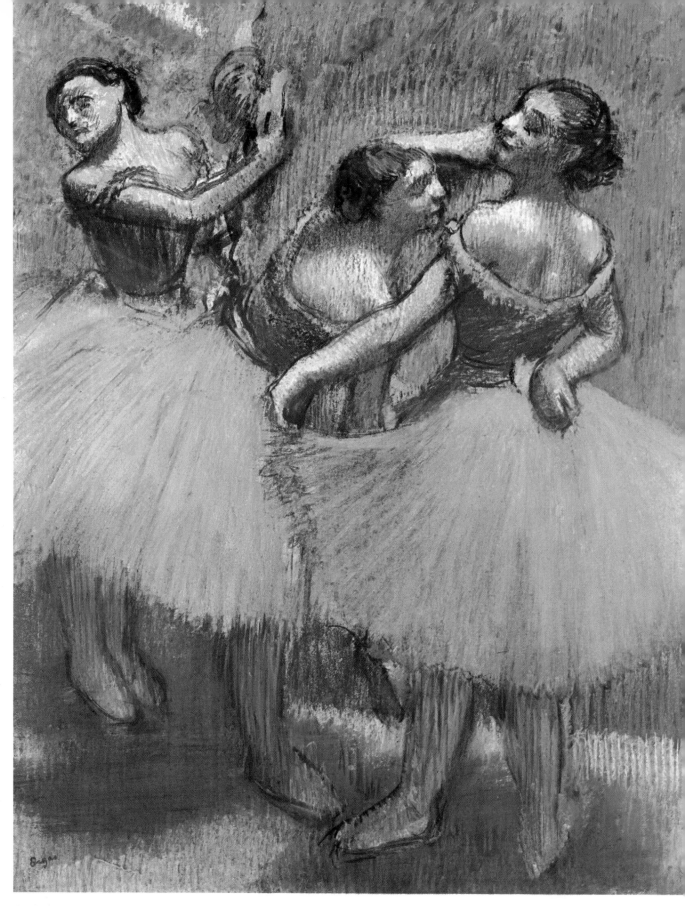

41. *Three Dancers with Green Bodices* - 1900. Private collection, USA

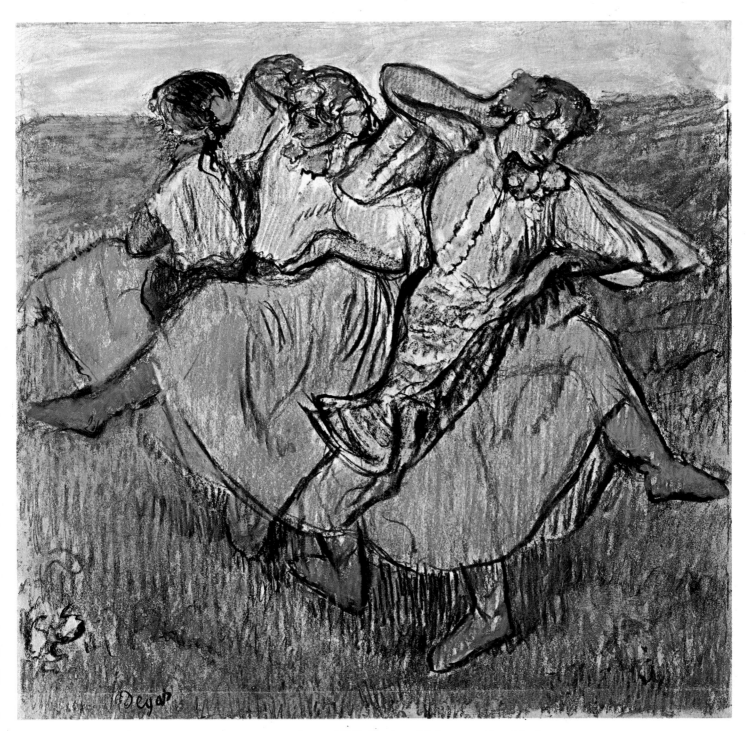

42. *Three Russian Dancers* - about 1895. National Museum, Stockholm

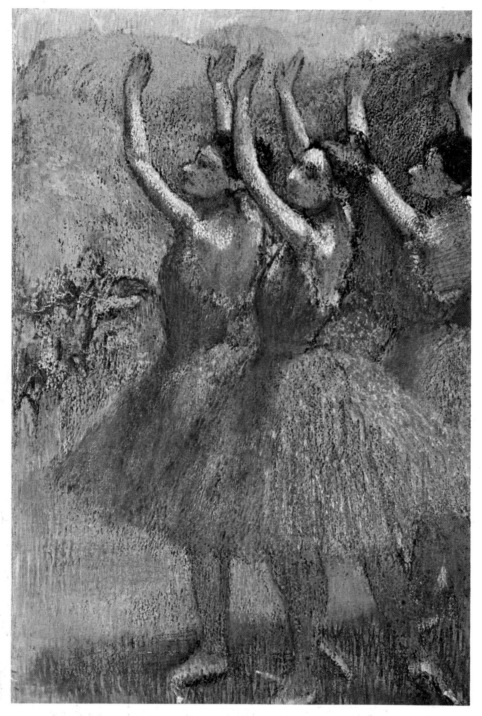

43. *Three Dancers, Violet Skirts* - 1898. Private collection

44. *Blue Dancers* - 1890. Musée du Louvre, Paris

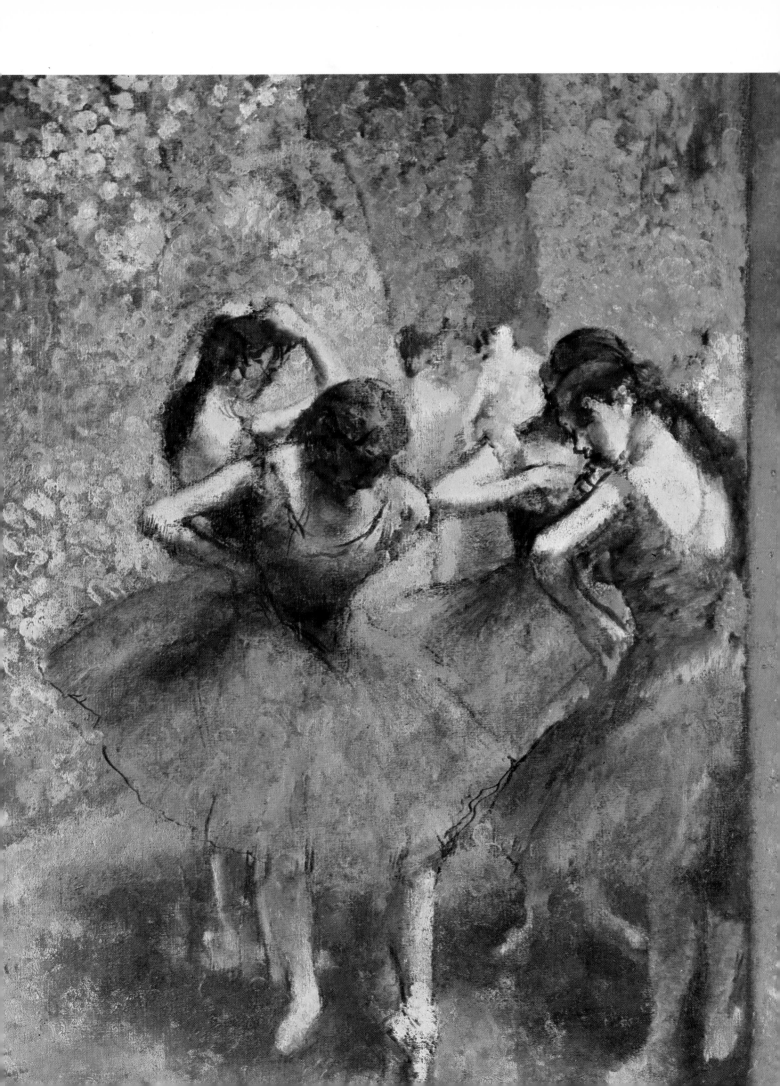

Editor in chief Anna Maria Mascheroni

Art director Luciano Raimondi

Text Marina Robbiani

Translation Kerry Milis

Production Art, Bologna

Photo Credits Gruppo Editoriale Fabbri S.p.A., Milan

Copyright © 1988 by Gruppo Editoriale Fabbri S.p.A., Milan

Copyright © 1990 by PHIDAL
for the Canadian edition

ISBN 2-89393-047-6

Printed in Italy by Gruppo Editoriale Fabbri S.p.A., Milan